iPad

for

Artists

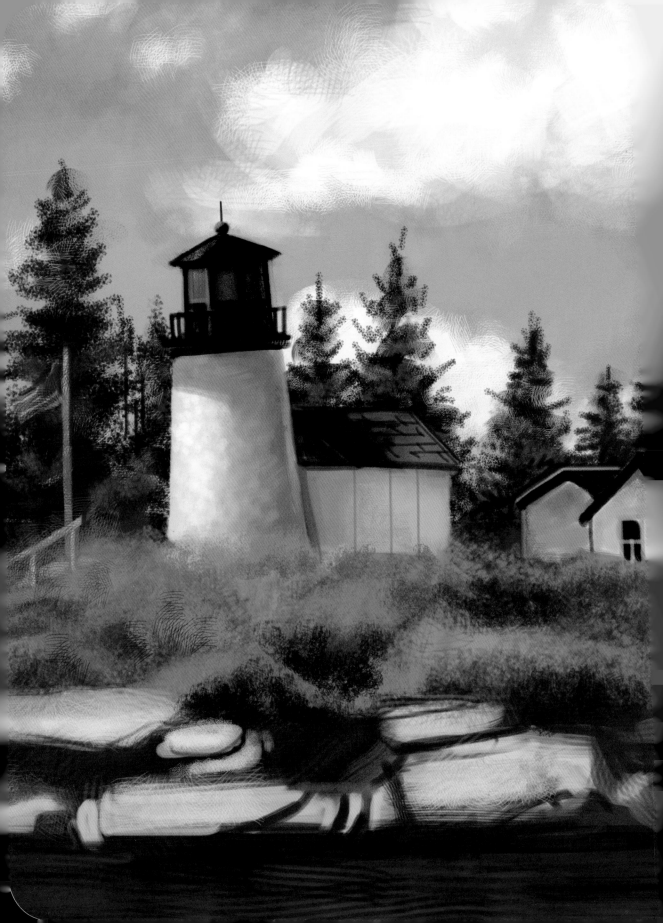

iPad

for
Artists

Dani Jones

Asheville
An Imprint of Sterling Publishing Co., Inc.

iPad for Artists

Library of Congress Cataloging-in-Publication Data

Jones, Dani, 1983-
 iPad for artists / Dani Jones. -- First Edition.
 pages cm
 ISBN 978-1-4547-0760-8
 1. Digital art--Technique. 2. iPad (Computer)--Amateurs' manuals.
I. Title.
 N7433.8.J66 2012
 776'.2--dc23
 2012006459

10 9 8 7 6 5 4 3 2 1
First Edition
Published by Pixiq
An Imprint of Sterling Publishing Co., Inc.
387 Park Avenue South, New York, N.Y. 10016
© The Ilex Press Limited 2013
All illustrations are copyright Dani Jones unless otherwise noted.

This book was conceived, designed, and produced by:
ILEX, 210 High Street, Lewes, BN7 2NS, United Kingdom

Publisher: Alastair Campbell
Creative Director: James Hollywell
Executive Publisher: Roly Allen
Managing Editor: Nick Jones
Senior Editor: Ellie Wilson
Commissioning Editor: Emma Shackleton
Art Director: Julie Weir
Designers: Chris & Jane Lanaway
Color Origination: Ivy Press Reprographics

Distributed in Canada by Sterling Publishing,
c/o Canadian Manda Group, 165 Dufferin Street
Toronto, Ontario, Canada M6K 3H6

Every effort has been made to ensure that all the information
in this book is accurate. However, due to differing conditions,
tools, and individual skills, the publisher cannot be responsible
for any injuries, losses, and other damages that may result
from the use of the information in this book. Because
specifications may be changed by the manufacturer without
notice, the contents of this book may not necessarily agree
with software and equipment changes made after publication.

If you have questions or comments about this book,
please contact:
Pixiq, 67 Broadway, Asheville, NC 28801
(828) 253-0467

Manufactured in China
All rights reserved
ISBN: 978-1-4547-0760-8

For information about custom editions, special sales,
premium and corporate purchases, please contact Sterling
Special Sales Department at 800-805-5489 or specialsales@
sterlingpub.com. For information about desk and examination
copies available to college and university professors, requests
must be submitted to academic@sterlingpublishing.com.

CONTENTS

INTRODUCTION

Let me take you back to April 3, 2010. I was eagerly awaiting (or more accurately, obsessing over) the arrival of my new iPad, which I had pre-ordered a few weeks before.

I am a technology nut, especially when it comes to making art, Apple computers, and tablets. I work full-time as an illustrator and create my work digitally. Before the iPad, I already owned three drawing tablets (now I have four), a tablet computer, an iMac, an iPod Touch, and an iPhone. I love the process of digital painting and regularly write tutorials on my website to teach other artists about art software and techniques. So when the iPad was first announced, let's just say I was more than a tiny bit excited.

When the delivery man finally showed up on my doorstep and handed over my new toy, I tore up the pretty box and immediately set to work putting it through its creative paces. Among the first iPad apps I ever bought were Brushes and SketchBook Pro.

But after I'd made no more than a scant few marks, I felt like I had the drawing skills of a two-year-old.

If you've ever taken a stab at drawing on an iPad, I have no doubt that you've gone through a similar emotional roller coaster. Let me assure you, you are not alone, and it is not as bad as it seems! As evidenced by this book, I got over my iPad woes eventually. It was just a matter of slightly rethinking my techniques, readjusting my expectations, and having fun. The iPad, being such a unique and versatile mobile device, is definitely worth the ride!

BELOW The iPad is just one of a number of tablet computers currently available.

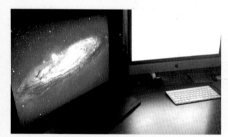

Wacom Cintiq Tablet

Modbook

iPad

Why Most Artists Are Afraid of Drawing on the iPad

Nowadays, there are lots of options for digital artists, everything from graphics tablets to tablet screens to tablet computers.

The iPad is in a different class of devices. It was not built for painters, but for general consumers. Favoring simplicity and ease of use over drawing, it lacks a few key features that are standard in other devices.

Pressure-sensitivity
Pressure-sensitivity lets you control your line or paint strokes depending on how hard you push on the screen. While most artist tablets will boast anywhere from 256 to 2048 levels of pressure-sensitivity, the iPad doesn't have any.

Pen Stylus
The iPad is designed to be used with the touch of a finger instead of a pen, which can make drawing or writing on the device pretty awkward. And even though lots of third-party companies are making styluses for the iPad, their blunt tips more resemble that of a dull ten-year-old Sharpie from the bottom of your desk drawer than a fine art pen or pencil.

Size/Resolution
Because the iPad is designed for extra mobility, processor speed and screen resolution is lower than your average laptop or tablet computer. The increased power and retina display in the newest third-generation iPad is an improvement, but creating high resolution, professional quality artwork is still a challenge in most painting apps.

So, given these weaknesses, it's no wonder that many artists balk at using the iPad for art. I commonly hear things like, "There's no way I can make good art with my finger" or "I'll buy an iPad when it gets pressure-sensitivity" or any other number of excuses, fears, and complaints.

Then there is another class of people that are ignoring all that and are simply making great art. The iPad is such a relatively brand new device and has redefined a whole

new class of computing, it's no wonder there would be a few hiccups; but it's amazing that it can already be used to make such tremendous art! Take a look around the internet. Skim through the images in this book. There's no doubt in my mind that the iPad is a powerful drawing, sketching, and painting tool.

To me, complaining that the iPad has no pressure-sensitivity is like saying that watercolor paint is transparent. It is what it is, but you can work around it. It doesn't mean you can't make great art with it, and have fun doing it.

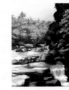

Difference in scale between the typical size of a painting on the iPad (right) and the size needed for professional print (far right).

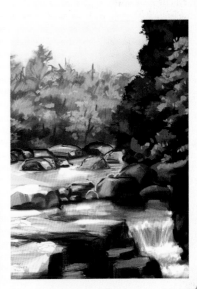

INTRODUCTION

Why Painting on the iPad is Awesome!

So why do I insist that you give drawing on the iPad a try? Surely you can buy other devices with more features, right? Why go through the headache of using a device with such rudimentary drawing capabilities in comparison to other art tablets? Shouldn't you just wait until the iPad gets pressure-sensitivity and a pen stylus?

And to that I say—WHY? Why wait? Tons of artists are making great art on the iPad right NOW. Despite its weaknesses, the iPad is a superior device in other areas, such as:

Mobility

A lot of artists are keen to make art on the iPad for one simple reason: it's so easy to carry around!

There are certainly more powerful digital art tools available, but you will be hard pressed to find one as small, light, versatile, and easy-to-use as an iPad. Take any other standard graphics tablet on the road, and you will also be packing a laptop, extra cables, and bulky power adapters.

The iPad is just as handy as your everyday sketchbook, but with the ability to carry loads of art software and tools (not to mention your music, movies, books, web browser, Angry Birds, etc.).

Simple Apps

If you've ever opened Adobe Photoshop or Corel Painter and been overwhelmed by all the tools and features, you will appreciate just how easy to use most of the iPad art apps are. Even the most fully featured "pro" apps take only a few minutes get used to. And while they're simple, good design and innovative tools still make the apps powerful and fully capable of creating impressive art.

BELOW LEFT One of my first iPad sketches, done in SketchBook Pro.

BELOW A landscape painted in Brushes, a simple yet versatile app.

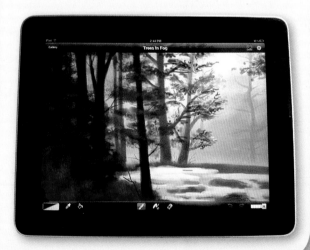

Strong Development and Quick Advances

The iPad and other iOS products have some of the most creative and innovative developers working for their platform. As I write this, the App Store has reached over 25 billion downloads. Third-party developers are creating an array of styluses (even pressure-sensitive ones!), painting apps, and other accessories to improve the drawing experience. The iPad itself has gone through major updates in the short few years that it has been on the market, both in software and hardware. Other devices simply cannot boast such talent, versatility, and devotion from their developers.

Can You Really Make Good Art on the iPad?

Yes! I would not bother writing this book if I didn't think so. The iPad is a powerful tool despite its weaknesses. Digital artists should not be so quick to dismiss it.

And to think, it can only get better from here. Time will only improve the hardware and software. Eventually, I think the iPad will get all these ideal features that artists keep talking about. In the meantime though, I'm not letting it stop me from trying out this device today, because it is tons of fun, innovative, and freeing.

Let me show you how.

LEFT AND ABOVE The iPad can be a powerful painting tool. Apps like ArtRage can create a realistic painting experience and offer real media effects.

THE BASICS

So you're excited about drawing on the iPad . . . now what?

As I've experimented with the iPad, I have downloaded a lot of art apps (thankfully, most apps are pretty cheap!). I've tried many styluses and I own about ten of them. While I'm still working on my trusty first generation iPad, I have also worked on the iPad 2 and the latest third-generation iPad (thanks to my Apple-loving family and friends). I've tried everything so YOU don't have to. Let my obsession be your guide!

So you're excited about drawing on the iPad . . . now what?

Whether you're shopping for your iPad or wondering which apps to download, this chapter will cover everything you need to get started. I'll cover which iPad features you need, and which you don't. I'll also discuss which iPad stylus is my favorite, and what I think are the most essential apps.

I've tried everything so YOU don't have to. Let my obsession be your guide!

I'll let you know which iPad features you need and, those you don't . . .

HARDWARE

Choosing Your iPad

In terms of art-making, there is not a lot of significant difference between iPad models. They all have the same touch capabilities and will run most of the same apps. Battery life is about the same. While the different models vary slightly in size and weight, they are all extremely handy and mobile. However, if you want to nitpick, there are some things to think about while shopping:

Old or New iPad?

If you are wondering whether to get a brand new iPad, find an older second-hand model, or upgrade your current device, here are the key differences and what they mean for your drawing apps:

Speed

New iPad models will run faster than the older ones. This matters for some art apps like ArtRage that simulate real-world paint, as they will start to lag when trying to render complicated effects.

Resolution

The screens on the first-gen iPad and iPad 2 are the same at 1024 x 768 pixels. The latest third-gen iPad, however, has a much higher quality retina display that is 2048 x 1536 pixels. That means images will look a whole lot sharper.

The faster processors and increased memory in newer iPads also means they can handle higher-resolution files. That in turn means some apps will be able to support bigger artwork, larger than the default 1024 x 768 pixels.

Camera

Many art apps let users import photos to use as reference, backgrounds, texture, or collage elements. A camera is also useful to quickly "scan" a sketch you want to color. If you want the capability to take

Second-hand iPad

New iPad

My first generation iPad.

Some of the art apps on my iPad.

photos, you will need an iPad 2 or later, as the first-generation iPad does not have a camera. Also note, the third-generation iPad has a much better quality camera than the iPad 2, jumping from less than one megapixel to five megapixels.

Compatibility

In my experience, most art apps will run on any iPad. However, a rare few may not run on the older first-gen iPad, or some of the features may not work (such as exporting artwork at higher resolution).

Specs

For every iPad model, there are two key features you have to decide upon:

Storage

The iPad comes with 16, 32, or 64 GB worth of space. The amount of storage you have will determine how many apps and sketches you can keep on your device (not to mention movies, games, and music!), so I usually recommend buying as much as you can afford.

Connectivity

All iPads have the ability to connect to the internet via WiFi. You can also pay extra for the ability to connect over 3G mobile data signals (or 4G, on third-generation iPads). In my opinion, this feature is not absolutely necessary for artists, since you can paint just fine without an internet connection. However, if you plan to take your iPad on the road a lot, it might be useful for syncing and saving sketches or downloading new art apps.

My iPad

Almost every drawing and painting you'll see in this book was created on my first generation iPad that I got that fateful day in April 2010. It has few bells and whistles, but I did splurge on 64 GB worth of storage capacity. I've never had a great need for 3G connectivity, and I've been able to handle about a gazillion art apps and many, many sketches on it. I've only had minimal speed problems in some of the more intensive apps, but all-in-all, this machine is still kicking and working great!

Final word

So, in other words, after everything I've just said about iPads and specs and features, it doesn't really matter which iPad you buy; they are all awesome!

STYLUSES

To my mind, if you want to draw on an iPad, you need to get yourself a stylus. It's not impossible to create art with just your finger, but it will be a whole lot easier on your coordination and accuracy.

What to Look For in a Stylus

Size
Some styluses are tiny and fit in your pocket, while others are shaped like thick magic markers. Choose a size that suits your style of drawing and is comfortable to use. Some artists prefer the ultra-portability of the small styluses, while others find the large styluses easier to handle.

Weight
A lot of styluses are made of plastic and aluminum, which makes them very light. I prefer a stylus that has a little bit of weight; it makes them feel more like an actual pen and gives them ergonomic balance.

Construction
There are a lot of cheap styluses on the market today, but in my experience, it is worth investing in a nice, sturdy stylus. I have bought several styluses only to have the tips wear out or clips break.

Accuracy and Responsiveness
In general, the smaller the tip, the more accurate it is. This is especially important on the iPad because the touch capabilities are, by their nature, not very accurate.

However, tip size isn't everything. You want a stylus that responds quickly when it touches your screen. Some styluses require you to press really hard or position the tips in a certain way before the iPad registers it, which can be very frustrating. Two different styluses might have tips that look exactly the same, yet respond very differently. If you can, try out your stylus before you purchase it.

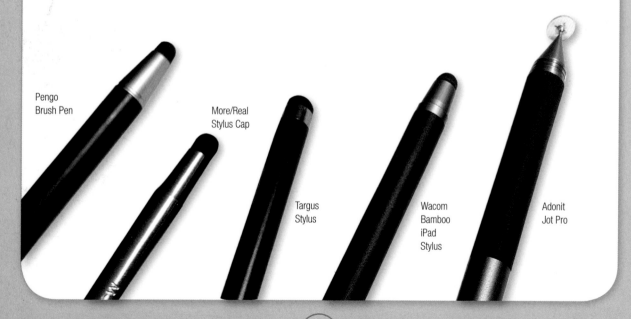

Pengo
Brush Pen

More/Real
Stylus Cap

Targus
Stylus

Wacom
Bamboo
iPad
Stylus

Adonit
Jot Pro

Getting to Know Your Stylus Tips

Foam/Rubber Tip

These are probably the most common type of stylus and feature a broad tip made to imitate the size and touch of your finger. They are not pointed like a pen, so it can be hard to be accurate. However, the tips are usually smaller than a fingertip, and it helps with the hand-eye coordination. These foam or rubber tips glide across the iPad screen well and are usually the most responsive type of stylus.

Plastic Disk Tip

These styluses use a flat circular disk instead of rubber. The clear plastic makes it easier to see where you are drawing on-screen. However, some people are uncomfortable hitting their expensive iPad screens with a hard piece of plastic or metal. Also, the plastic disks are generally less responsive than the rubber tips, so you might have to press harder in order for it to draw correctly. They also don't glide as steadily as other tips and tend to stick to the screen, especially if you have a film screen protector over your iPad.

Brush Tip

Brush tips use conductive fibers to create a more painterly experience. They do not offer much advantage in terms of accuracy or effect; the advantage of these styluses is more in how they feel when you use them, and they are very responsive. They are not great for all-purpose sketching and writing, but they are fun to have around, and artists who have a background in traditional painting might enjoy them.

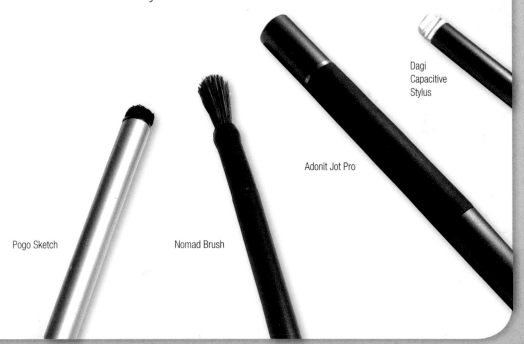

Dagi Capacitive Stylus

Adonit Jot Pro

Pogo Sketch

Nomad Brush

STYLUSES

My Favorite Styluses

I have a minor obsession with iPad styluses and own way too many—more than I need. In reality, there are only a few that I use on a regular basis. No matter how many styluses I try out, these few continue to be my go-to iPad drawing tools for their quality and accuracy.

Jot Pro
By Adonit http://adonit.net

The tip on the Jot stylus is a plastic disk attached to a metal point. The disk is clear plastic, which helps you see where the point is drawing. It looks and feels like a typical ballpoint pen.

It is made of durable metal, and is weighted so it feels comfortable to use. It is also magnetic and will cling to the iPad 2 or later. It is one of the most accurate, well-constructed styluses I have come across so far.

Bamboo Stylus
By Wacom http://wacom.com

Wacom is already well known in the digital art world for their superior tablets and pen technology. They live up to their name with this fine iPad stylus. It has a nice weight, is well constructed, and is probably the most accurate of any of the rubber/foam-tipped styluses I have tried. The tip is also quicker and more responsive than the Jot Pro and most other styluses.

> **Notes**
>
> Do not confuse the Wacom Bamboo iPad Stylus with the Wacom Bamboo Tablet. The tablet is the device that plugs into a USB port and is meant for drawing on a computer. The pen that comes with the tablet will NOT work on an iPad. The Wacom Bamboo iPad Stylus is a completely separate device.

Pogo Sketch
By TenOne Design http://tenonedesign.com

The Pogo stylus is arguably the first notable stylus made for touch screens. I was using one to draw on my iPhone long before the iPad even existed. The basic design features an aluminum tube and a foam tip. I enjoy how small and portable this stylus is, but some artists may find it too lightweight.

Pogo Sketch

Jot Pro

Stylus tips

Pogo Sketch

Jot Pro

Jot Pro

Bamboo

Bamboo

Nomad Brush

By Nomad Brush http://nomadbrush.com

The Nomad stylus is one of the most talked about brush styluses for the iPad. It looks and feels exactly like a watercolor brush with a long handle and bristles made out of a conductive fiber.

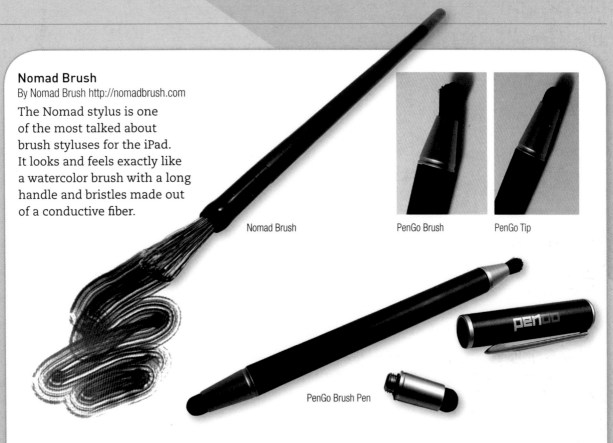

Nomad Brush

PenGo Brush

PenGo Tip

PenGo Brush Pen

The Nomad brush feels exactly like a watercolor brush when you are painting with it.

The bristles on the Nomad brush are made of conductive fiber that responds to the iPad's touch screen.

PenGo Brush Pen

By PenGo http://pengocreative.blogspot.com

The PenGo stylus is one of my recent favorites simply because it features interchangeable tips, including two different sized rubber tips and a brush. In terms of tips and comfort, I like the Wacom Bamboo and Nomad Brush better, but it is a solid and versatile all-in-one tool if you don't want to carry a bunch of different styluses with you.

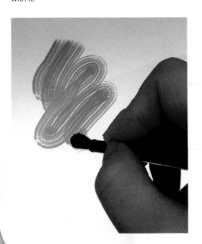

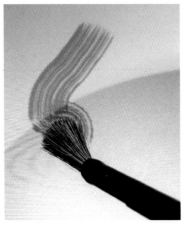

SOFTWARE

Apps! The list of art apps available for the iPad seems to grow every time I visit the App Store. There are a few professional frontrunners, and a lot of standout smaller apps as well. It amazes me how developers are coming up with innovative ways to tackle the iPad's limitations for drawing and painting.

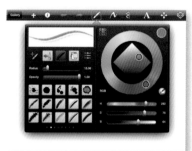

SketchBook Pro brushes

What to Look For in an Art App

There are many reasons to pick one art app over another, but for me it almost always comes down to a few things:

Tools

What types of tools does the app provide? How do they work? Some give you a few basic brushes, while others have an assortment of pens, pencils, and textured brushes.

Interface

How easy is it to get around the app? Can you find and access tools easily? With so many apps featuring similar painting tools, the interface is usually what sells me on a specific app. SketchBook Pro, for example, is a complex app with many settings or tools, but it is easy to navigate with its spectacular user interface.

Procreate tools

ArtRage interface

File Management/Export

Can you export your work via email, iTunes, or third-party apps? What formats can you save in? Some apps will export layered Photoshop files or vector work, which is great if you intend to refine your sketches in your desktop software. Others only export flattened copies of your image to your photo library.

Procrete interface

Pixels or Vectors?

Some apps are pixel-based, meaning the image is made up of tiny dots of color. Most "painting" apps like ArtRage and Brushes are pixel-based. They allow for a lot of texture and nuance in the image. However, because the images are limited to a certain number of pixels, pixel-based images cannot be enlarged without becoming blurry. This is a handicap for the iPad in particular because a lot of art apps only support low-resolution (usually 1024 x 768 pixels) images, so they can't be used for most pro work.

Vector-based apps, on the other hand, create images via mathematical calculations and coordinates. The app records the relative size and dimensions of each stroke and shape. Vector images are usually limited to basic shapes and lines and don't allow for a lot of texture, but the images can be enlarged to any size without any blurriness or pixelation. These kinds of apps are great for line art and icons. Examples of vector-based apps include Adobe Ideas, iDraw, and Inkpad.

ArtRage pixel-based app texture

Inkpad vector-based drawing paths

Inkpad vector-based path

Universal app

View In iTunes

⊕ This app is designed for both iPhone and iPad

Universal Apps

Do you own an iPhone or iPod Touch in addition to your iPad? Most art apps I've come across require that you buy a different version of the app for each device (for example, I can use SketchBook Pro on my iPad, but I had to buy SketchBook Mobile separately for my iPhone). However, there are a few universal apps that support both within one app, such as Adobe Ideas.

Video

A few apps record your painting process as you go. This allows you to playback the painting. You may even be able to export the video and save it to your computer or share on the web. Brushes, ArtRage, and Layers all support video playback.

MY FAVORITE IPAD ART APPS

Here's a list of some of my favorite apps. Many of these will be used prominently throughout the course of this book.

SketchBook Pro
Autodesk, Inc.
http://autodesk.com

SketchBook Pro was an early frontrunner on the iPad and strives to be the best of the digital sketchbooks. There is a variety of drawing and coloring tools, including pens, pencils, and a library of brushes. You can download additional brushes too. The interface is one of the best designed and easy-to-use, which makes it one of my favorites.

ArtRage
Ambient Design Ltd.
www.artrage.com

This app attempts to simulate real-world media and painting techniques. It features some of the best paint simulation I've seen on the iPad. The app can set a specific texture for the canvas or remember how "wet" your paint is. You can blend colors as you are working, and even spread your paint with a palette knife! If you are a fan of the ArtRage desktop software, or its similar competitor Corel Painter, you will probably love this app on the iPad.

Adobe Ideas
Adobe Systems Incorporated
www.adobe.com

This is a simple little app. There is only one brush and a few basic controls. It is a vector-based app, but it's not a traditional vector graphics program (it's missing things like a pen tool, selection tools, etc.). However, there is a lot to be said for simplicity. The app is boiled down to the sole purpose of sketching concepts quickly and easily. It's faster and more responsive than the more loaded apps, and I love how smoothly the brush draws. I've come to enjoy it for doodling and inking.

SketchBook Pro pros and cons

Pros
Variety of tools; intuitive interface

Cons
The amount of tools and settings might be intimidating; other apps have better "real-world" painting effects (oil paint, watercolor, etc.)

Best for
All-around sketching, concept art, storyboarding

ArtRage pros and cons

Pros
Great real-world painting tools

Cons
The simulated effects may make the program slow and less responsive

Best for
Traditional painters, landscape and portrait painting

Adobe Ideas pros and cons

Pros
Universal app; vector-based output means you can resize/zoom images to any size; smooths your strokes as you draw

Cons
Very basic brush tools and functionality

Best for
Quick concepts, sketching, inking

Brushes
Taptrix, Inc.
www.brushesapp.com

Brushes is a traditional favorite among iPad artists. Images created in Brushes have been featured on the cover of The New Yorker! It has the ability to record as you draw; you can play back your painting stroke-for-stroke, and export the video when you're done!

Brushes pros and cons

Pros
Great all-around sketching app; video export

Cons
Not as many brushes or tools as other apps like SketchBook Pro

Best for
Quick color sketches

Procreate
Savage Interactive Pty Ltd.
http://savage.si

Besides being a solid painting app, Procreate is the first app I've come across that lets you create your own custom brushes using your own photos and textures. You can also control scattering, wetness, grain, and other brush features that are not available in most other apps.

Procreate pros and cons

Pros
Great brush options; well-designed interface

Cons
On iPad 2 and above, Procreate can create higher-res "HD" artwork (1920 x 1480 pixels), but if you're still on a first-gen iPad, the canvas is only 960 x 740 pixels (less than most other apps)

Best for
Painting, concept work, and all-around sketching

Inkpad
Taptrix, Inc.
www.taptrix.com

Inkpad is my favorite app for creating traditional vector work. You can create your paths with a pen tool, or draw them on with a brush. There are also many ways to edit your paths, including erasing, outlining, joining, and masking.

Inkpad pros and cons

Pros
Very versatile vector-based app

Cons
I love it for inking and finishing work, but it's not my favorite app to sketch in (I like the brush in Adobe Ideas better)

Best for
Line work, logo and icon design, graphics

Fun honorable mentions

I may not use these apps all the time, but they have notable fun features you might want to try.

Whiteboard Pro
By GreenGar Studios

Want to draw with your friends? With Whiteboard Pro, you can connect to nearby iOS devices via Wi-Fi or Bluetooth and draw on the same picture together! Each person's screen is updated live as you draw.

iFontMaker
Eiji Nishidai
http://2ttf.com

iFontMaker is a font editor for the iPad. You can hand-draw your own typeface and export it for use in your desktop software. A great art app for designers, comic artists, and scrapbookers.

123D Sculpt
By Autodesk Inc.

If you enjoy clay more than pencils and paints, use this app to sculpt your own three-dimensional creations.

Sketch Club
By Blackpawn.com

A fun little sketching app that has a community built right into it. Upload your sketches, record and post a time-lapse video to YouTube, and browse through other artists' work all within the app. There are also sketch challenges and competitions.

TOOLS AND SETUP

When you first open up any drawing app on the iPad, there are several things you are going to want to look for right away. These features are generally universal across all art apps. You will want to learn 1) where they are, and 2) how best to use them.

Canvas Settings

How do you set up a new document? Can you change the size? What other settings can you change before you even start drawing?

In ArtRage, for example, you can change the texture of the canvas itself, which will affect your entire painting. There is an array of canvas and paper presets, and you can also adjust different settings to your own liking.

Brush Settings

How do you change the size of the brush? How about the opacity? What other settings can you adjust?

Many apps will have a dedicated brush palette or panel where you can adjust individual settings. Some apps also provide additional on-screen sliders, controls, or gestures that you can access extra quickly while you are painting. Also check to see if the app has the ability to save brush presets so you can adjust a brush to your liking and keep it for future use.

Many of the art apps will also have brushes influenced by real-world tools. For example, in SketchBook Pro you can pick from a pencil, marker, pen, or paintbrush. This is a very handy way to switch brush types and settings on the fly.

Color Picker

How do you change the color of your paint? You will usually find some or all of the following:

Color Spectrum

Some kind of wheel or box showing all available colors that you can drag your finger across to pick a color.

Canvas textures

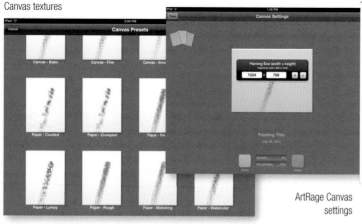

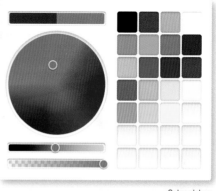

ArtRage Canvas settings

Color picker

Swatches

A defined set of preset colors. Some apps have the ability to save custom swatches.

Sliders

Usually HSB (hue, saturation, brightness), RGB (red, green, blue), or CMYK (cyan, magenta, yellow, black). You can slide these back and forth to change specific qualities of a color.

Eyedropper Tool

The eyedropper lets you pick colors straight from your artwork. This is one of the most common ways I switch colors as I paint. It is an important tool for choosing and blending colors. With some apps, you can tap and hold on the screen. Others have a dedicated button.

Zoom and Move

How do you move around the painting? Most art apps work with the standard iOS pinch, touch, swipe, and tap effects. For example, you can often use the pinch gesture to zoom in and out. Experiment to see what works for the app, or look up in their documentation for any special gestures you may need to know.

Layers

Almost all art apps support at least a few layers. It's a handy way to save various stages of your drawing, or separate different elements (for example, to keep the sketch separate from the color).

The Undo Button

As with any kind of digital artwork, you will probably need this. A lot. Find out where it is.

Eyedropper tool

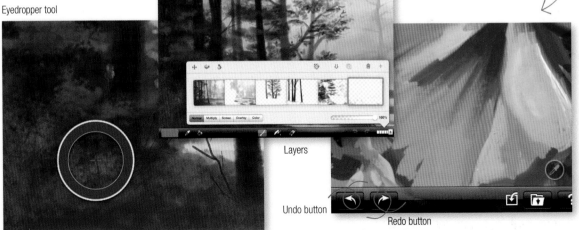

Layers

Undo button

Redo button

MANAGING FILES

How do you get your artwork off your iPad and into your computer and back again? On a normal laptop computer, you can connect to your file system over a wireless network, burn a CD, or copy files onto a thumb drive. On the iPad, it is not so clear cut and there's no great overarching solution yet. Because each app is sandboxed independently of one another, every app handles file management in a different way, and it's not easy to share files between apps.

Some apps provide app-specific ways for syncing files, either through their own web server, cloud service, or desktop application. However, almost all will provide some of the following options as well:

Photo Library

Most apps will let you save your images to the Photos app on your iPad, which in turn can be synced to your computer. Images saved to your photo library are not the original file, but are copies in JPEG or PNG format. This discards things like layers and paths, which are handy for further editing and refining. Because of this, it is not ideal if you intend to edit or resize the artwork, but it is probably the most convenient way to move a sketch created in one app into another because iPhoto is easily accessible throughout iOS.

The photo library is also handy for moving images to your computer or other devices. If you have iCloud with Photo-stream set up, when you save a file to your photo library on your iPad, it will automatically stream to all your devices for easy access.

iTunes

You can also sync files through iTunes when you connect your iPad to your computer via USB or WiFi. After the iPad is connected, open iTunes and click on your iPad in the source list. Select the Apps section at the top. At the bottom of this section, there is a list of apps available for file sharing, along with a document list for each app. You can click and drag files out of the app using the document list. In some apps you can not only export files this way, but also import files into the app from other sources.

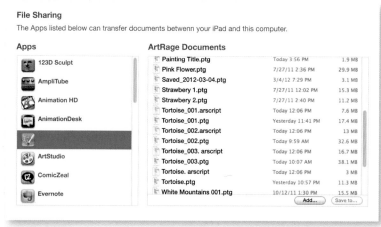

iTunes File Sharing

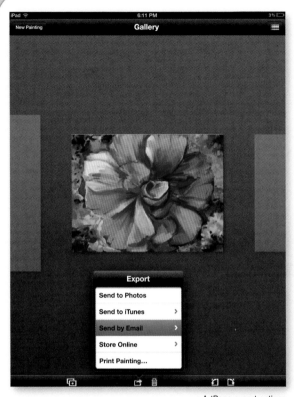

ArtRage export options

iCloud

iCloud is Apple's online syncing and storage service. iCloud is best for syncing files automatically between multiple iOS devices. For example, I can draw a sketch in SketchBook Mobile on my iPhone, and when I open SketchBook Pro on my iPad, the file is already there and ready for me.

SketchBook Mobile iPhone iCloud sync

Email

This will send your file as an email attachment, which you can then access from your computer or other device.

Dropbox

Dropbox is a third-party app and is similar to iCloud in that it provides online storage and syncing between devices. I like Dropbox because not only does it sync across iOS devices, but to my desktop computer as well. http://www.dropbox.com

DRAWING AND SKETCHING

▪▪▪▪

I'm not gonna lie—learning to draw on the iPad can be rough. I felt like I was a kid again learning to write my first words, frustrated that my marks weren't looking as pretty as I wanted. But as I got used to the process, it became easier, and drawing no longer seemed like a monumental task. (Well, as far as the iPad was concerned anyway. Drawing is still a hard skill to master!)

Learning to draw on the iPad can be rough, but it does become easier

The hardest challenge you will face is control. If you take a look at my first attempts in SketchBook Pro, you can tell instantly that they were made on an iPad. The lines are rough and inaccurate. I could barely color inside the lines.

Let's take a look at some iPad drawing techniques. Then we'll begin creating some actual artwork!

The hardest challenge you will face is control. I could barely color inside the lines

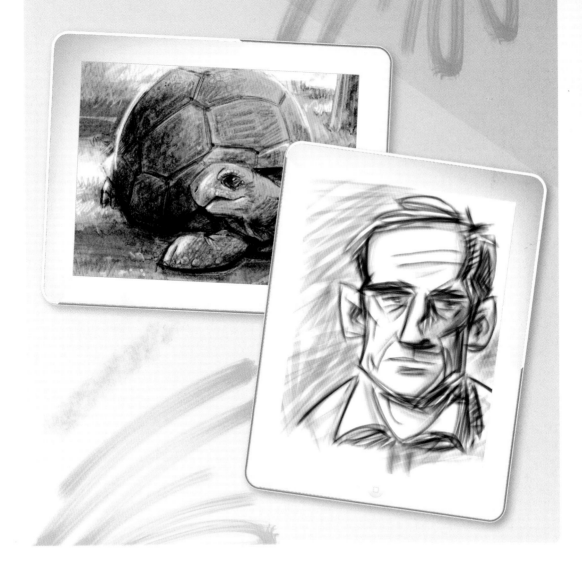

TIPS FOR DRAWING THE IPAD WAY

While learning to draw on the iPad, I had to both change my mindset and physically practice my hand-eye coordination with the broad stylus. Although I was frustrated at first, it really didn't take that long to get used to it. It just takes a little practice.

Rearrange Your Thinking

Set Realistic Expectations
A graphics tablet, the iPad is not. It is also not your traditional sketchbook and has many advantages. I think comparing the iPad to other devices and media is the wrong way to go.

Approach drawing on the iPad as a new experience. Start from scratch and get to know your apps and the limitations of your tools. Too many artists are frustrated by the iPad because they are trying to use it as something else, but you can have a whole lot more fun if you keep an open mind from the start.

Start off with broad strokes using smaller and lighter brushes to sketch very roughly.

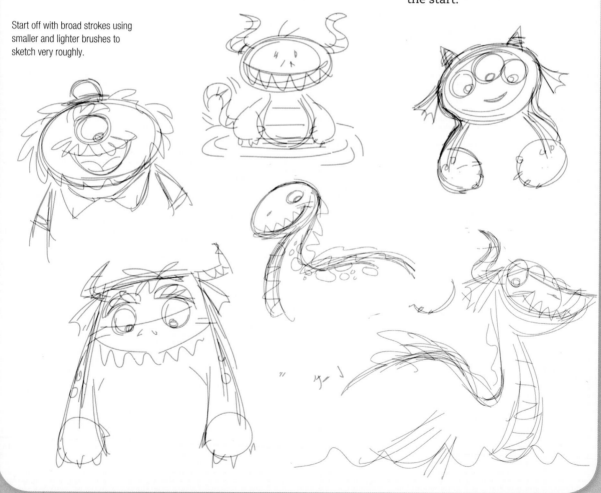

Stay Loose

I've found the best way to get over my frustration with the iPad is to just go with it! The iPad may not be the greatest device for precision, but it still works beautifully for rough sketching and color, which is just fine because you don't need very precise details until the very end of your drawing or painting anyway. When I paint traditionally, I start with large brushes and broad strokes; I take that same sensibility to the iPad. Learn to stay as loose as possible and gradually work your way up. If you try to make exact lines right from the get-go, you will mostly likely find yourself disappointed.

Gradually build darker and more accurate lines as you progress with your drawing.

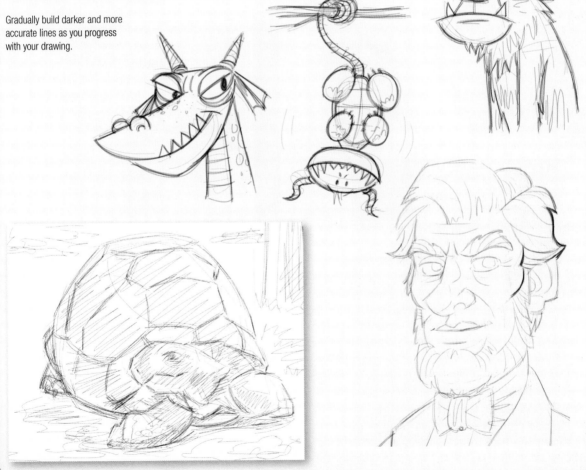

TIPS FOR DRAWING THE IPAD WAY

Take Control of Your Line

Zoom In

When I first started drawing on the iPad, I didn't zoom or move the canvas around a lot. I was treating my iPad like a traditional sketchbook with static pages. Take advantage of the iPad's strengths! Remember that you can magnify your drawing space and move the sketch to a comfortable position. It is easier to be accurate when you zoom in, and lines will look a whole lot cleaner when you zoom back out.

Work Lightly

Drawing on the iPad is rough stuff. No matter what you do, you will end up with some pretty ugly scribbles. In my first iPad drawings, I used brushes that were too dark—you could see every scratch and scribble I made. So now when I start a sketch, I put my brush on the lowest opacity setting possible so I can barely see the line (for me, this is usually 10% or lower). As I progress, I increase the opacity and size of the brush. When I'm done, you can barely see the sketchy mess I started with.

Use Layers

Another way to hide your rough early scribbles is to use layers. Most drawing apps have layering capabilities. I can block in my drawing as scribbly as I want, then start a new layer to create my refined lines. Then I can hide or throw away the first layer to instantly clean up my drawing.

Remember to zoom in!

This witch was created using layers

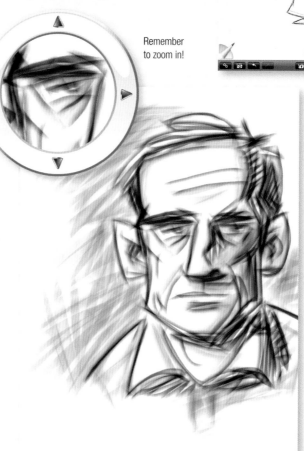

Rest Your Hand

The iPad's screen will register any touch of your skin, including your palm. That means you can't put your hand down on the drawing while you are working.

Tip

One object that works is a thin paperback book or magazine, which makes for a comfortable rest and is convenient because I often have one lying around.

1 There is an area of about an inch or so that borders the screen that is non-capacitive. I sometimes use this space to rest my hand upon.

2 I will also move my drawing to the right side of the screen (where my hand is) so I can draw comfortably. This works most of the time when I need a bit more control.

3 You can also try wearing a glove or resting your hand on a thick piece of cloth or paper, but I've found most material to be too thin to sufficiently block the touch of my palm (the iPad screen is pretty sensitive).

Shading: Start Basic

Remember to stay as loose and broad as possible. When you begin shading, keep it simple and stick with the basic light and dark patterns, then gradually work your way into the details.

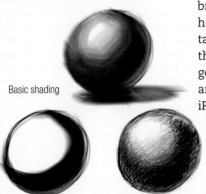

Basic shading

Texture

As with all digital drawing, texture is the best way to add visual interest and prevent your work from looking too "digital."

You can use special textured brushes or cross-hatch your brush strokes. When cross-hatching, I like to find a nice tapered brush that simulates the thick-to-thin you usually get with pressure-sensitivity, and avoid that uniform iPad look.

Cross hatching

Blending

Blending

Blend shades together by lowering the opacity of your brush and carefully overlapping brush strokes. You will have to start very lightly since you can't control the pressure of your brush. Soften edges by repeatedly going over them. Some apps also provide simulated paint blending and smudge tools.

TUTORIAL: Drawing a Portrait

First Drawing Tutorial

Let's start simple.
For this drawing, I am
going to make a simple
head portrait. It's a
good way to warm up
the drawing muscles
and practice control
and precision. Then,
I'll add some shading
and texture.

For this first drawing
tutorial, I've decided to
use the app SketchBook
Pro. It is a great all-
purpose drawing app.
It has a variety of tools
and well-designed
interface and I
generally recommend
it for beginning iPad
artists looking for a
well-rounded art app.

Final Image
This is the final image
after I have added all the
shading, texture, and
highlights to my sketch.

1 Setup

If the app doesn't already open into a new document, find and tap the plus sign to start one. Choose the pencil tool and change the color to black. You are now ready to start drawing!

2 The Rough

Block in your general shapes very lightly. For this stage, I typically set my brush somewhere around 5–10% opacity with a radius of 1–3. You should barely be able to see your line, enough to guide your drawing without making it all messy really fast.

The "puck"

Tap or slide the puck up or down to control the opacity of your brush and left and right to control the size.

Notes about the interface

There is a toolbar along the top. You will probably be most interested in the brush settings, which are in the very center. Also, there is a small dot at the bottom of the screen. If you tap it, you can access your drawing tools and various other things. Most importantly, SketchBook Pro has a unique feature called the "puck" in the center of the screen. Tap and slide up and down to control the opacity of your brush, and left and right to control size. It is handy and you will probably use it a lot.

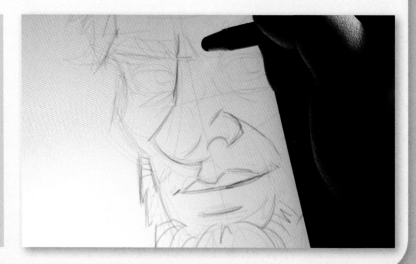

TUTORIAL: Drawing a Portrait

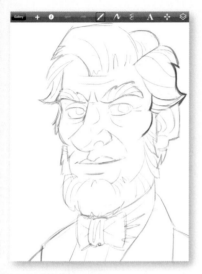

Keeping lines clean and precise

To keep your lines clean and precise, zoom in on the drawing. It's a lot easier to follow your rough outline, and messy strokes will be minimized.

3 Refine

As your details become clearer, gradually increase the diameter and/or opacity of your brush and draw heavier lines on top. If you want, you can always start a new layer to separate your rough drawing from your cleaner lines.

4 You'll probably still want to keep your brush opacity below 30–40% or so. Even with the low opacity, you can quickly build up pretty dark lines by drawing over the line repeatedly.

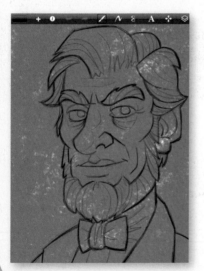

5 Shading

Start a new layer and place it underneath your line drawing.

Using the toolbar up top, open your brush settings. There are a variety of brushes available. I like a lot of texture, so I picked a pastel/charcoal-like brush.

I started by covering the entire layer with a middle-value gray color.

6 Increase Shade

Then, using a big and heavy brush, I drew in large areas of black. Use very large brushes at this stage at high opacity. Have fun and keep it rough.

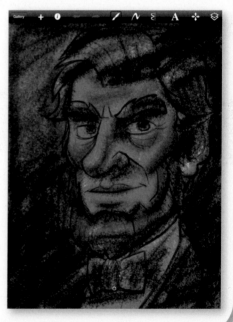

7 Create Contrast

Gradually build up your lights and darks. Use the swatch palette to switch between various shades of gray. You can also tap and hold on the drawing to select colors with the eyedropper tool. Lower the opacity of your brush to blend darks and lights together.

8 Details

As you get further along in the drawing, use smaller brushes and more precise brush strokes.
Eventually, I add another layer on top of my sketch layer. This is for putting finishing touches on my drawing and cleaning up any roughness left from my line drawing. Done! Tap the Gallery button to save your drawing.

Tighter details

Zoom in on the drawing to get tighter details.

Final image

TUTORIAL: Creating a Pencil Drawing

The iPad is not only great for digital artists, but for traditional drawers and painters as well. The iPad can be used to create beautiful work and can simulate a variety of real-world media.

For this tutorial, I'd like to introduce you to the app ArtRage. ArtRage has some of the best tools for traditional media artists on the iPad. Both the paint effects and interface are built to look and feel like a regular painter's palette.

A Walk Around the App

You can access your tools in the bottom corner (the button shows your current tool; it usually starts off with a paint-brush). There is a paintbrush, pastel, crayon, ink pens, and many more. For the majority of this tutorial, I'm going to use the pencil tool.

Some advice about ArtRage

Of the art apps I've worked with, ArtRage is definitely one of the most memory intensive. If you own an older first-gen iPad like I do, you may experience speed issues or crashes. ArtRage still works beautifully most of the time, but it's not a bad idea to save often. I've also found it helps to quit and reload the app occasionally, and shutdown any other apps that might be running in the background.

1 Setup
Open up ArtRage and create a new painting. You can select which type of canvas you want to work on by changing the grain or roughness controls, or use one of the built-in presets. For this drawing, I decided to use the "sketching" paper texture preset.

ArtRage lets you import a photo and pin it to your workspace to use as reference. Tap the reference button in the bottom right corner to access your photo library. I chose to draw this handsome giant tortoise I met at the zoo a few years ago.

You can reposition both your canvas and your reference photo by pinching or dragging with two fingers over the top of them. You can also hide or reset the position of your reference by tapping on the reference button again, and it will show all the reference photos you currently have pinned to your board.

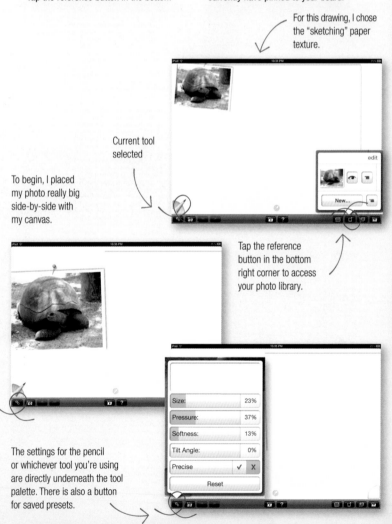

For this drawing, I chose the "sketching" paper texture.

Current tool selected

To begin, I placed my photo really big side-by-side with my canvas.

Tap the reference button in the bottom right corner to access your photo library.

The settings for the pencil or whichever tool you're using are directly underneath the tool palette. There is also a button for saved presets.

Size:	23%
Pressure:	37%
Softness:	13%
Tilt Angle:	0%
Precise	✓ X
Reset	

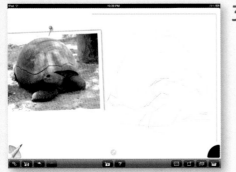

2 Block-In

The first thing I do when drawing is block in the general shapes very lightly with the pencil tool. One thing about ArtRage that confused me at first was that it doesn't have the traditional "size/opacity" controls you see in other digital painting programs. Instead, it has settings like pressure, softness, and tilt angle—types of qualities that are familiar to artists with a traditional media mindset. To create my block-in, I lowered the size and pressure of my pencil to make a very light line. I tried to stay very loose and think of only the most basic shapes.

I added very basic shading using hatched lines and scribbles.

3 Organize

When I got further along in my drawing, I noticed that I was a little too close to the right edge of the canvas. Thankfully on the iPad, it's easy to reposition your drawing. Tap the layers button in the bottom right corner. Then tap the layer options button and select "Transform layer." You can use the handles to resize and position the drawing more to your liking.

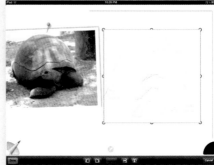

As I progressed with my blocking-in, I increased the size and pressure of my pencil.

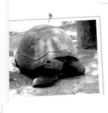

I went over my light lines with darker lines to bring out details.

4 Tone

Once I had a rough drawing I was happy with, I lowered the opacity of the layer and added a new layer underneath it. I filled the layer with a light gray color using the paint bucket tool. This is to create a toned paper effect. I then started a new layer to begin my final drawing.

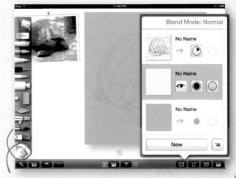

TUTORIAL: Creating a Pencil Drawing

Shading

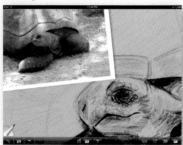

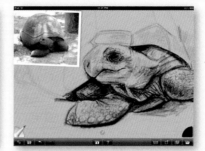

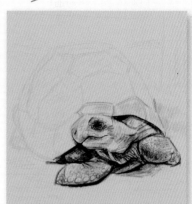

5 Increasing
I started by increasing the size, pressure, and softness of the pencil to draw the darkest lines around the eyes and face.

6 Decreasing
I then decreased the pressure to block in the lighter shades around them. I also increased the tilt angle of the pencil to make it easier to shade with.

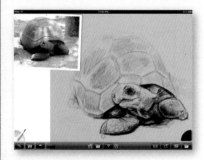

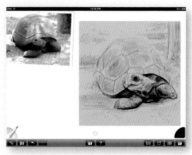

7 Adding Tighter Details
After shading very generally, I then decreased the size and softness of the brush so I could add tighter details, such as the scales on the tortoise's face and legs.

8 Blocking In Shades
After finishing the face, I used a pencil with a high tilt angle and low pressure to lightly block in shades on the shell and background.

9 Building Up Darks
I blocked in general shades using a broad pencil with a high tilt angle. I then built up my darks with large bold strokes.

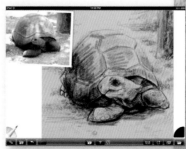

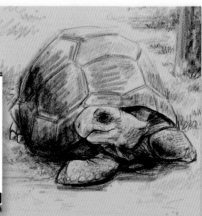

Other tools

Occasionally, I used the paint roller tool to block in large areas of shading or highlights. It's a whole lot easier than using the tiny pencil. I would do this on its own layer, because many times the paint roller would be too bold or flat to blend into the pencil drawing. On its own layer, I could lower the opacity and soften edges before merging with the rest of the drawing. To add scribbly textures and lift out darks where areas were too flat, I would use the eraser tool. And lastly, the palette knife is great for smudging the pencil and softening edges.

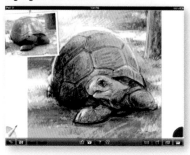

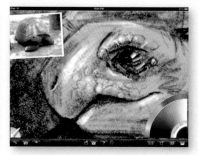

Highlights and Details

10 Adding Highlights
To finish off the drawing, I changed my color to white and added highlights to the background and the tortoise's face. I like how adding white to the toned background really makes the drawing pop.

11 Adding the Sharpest Details
Using small, bold pencil strokes, I zoomed in and added the sharpest details, such as the texture on the skin and shell, and highlights around the eye.

Eraser to add textures and lift dark areas

Paint roller tool to block in larger areas of shading or highlights

Palette knife to smudge and soften edges

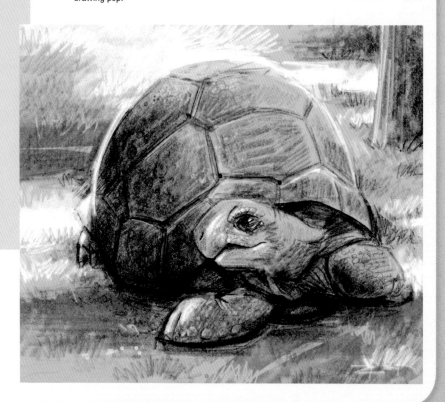

The finished drawing, fully shaded with highlights.

INKING

Creating line art on the iPad can be a challenge because it often requires great care and accuracy, which is hard to accomplish with blunt iPad styluses. And without pressure-sensitivity, you cannot easily draw interesting lines with variable widths or weights.

The first thing I recommend for creating line art on the iPad is to use a vector-based app. Most of these apps will help smooth your brush strokes as you are drawing. The lines will stay cleaner, and the vector artwork can be taken to your computer and resized without any image loss.

Without pressure-sensitivity, I have to use different methods in order to create interesting lines and mimic the effects of a brush or pen. These are a few of the ways that I create my line art.

Without pressure-sensitivity, drawing interesting lines of varying widths on an iPad can be a challenge, but you can work round it.

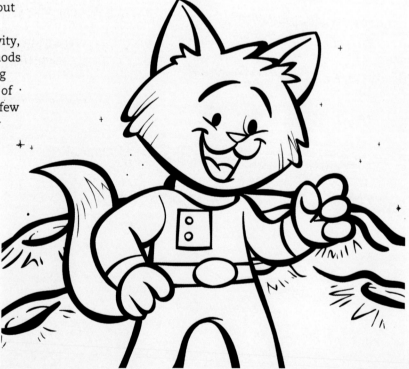

With practice and a rethinking of methods, you can create linework on the iPad that's even suitable for pro work. I drew this cat character for one of my comics completely on my iPad.

Draw and Erase

Size the brush to slightly larger than needed. Draw the line, then use the eraser tool to sharpen ends and simulate a thick-to-thin brush stroke.

Outline and Color

Use a small brush and draw two lines outlining where you want your brush stroke to be. Color in between the lines to finish your stroke.

Faux Brushes

Some apps have tools that simulate the thick-to-thin brush line by automatically adding a tapered end to each stroke. They can also simulate things like ink spatter or halftone printing. They are not always best for specific inking needs or effects, and some brushes look too fake if used improperly, but they can be great for adding an ink effect quickly and easily.

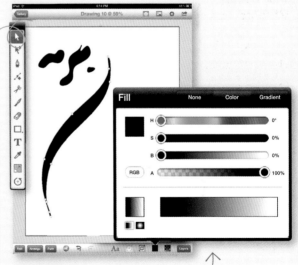

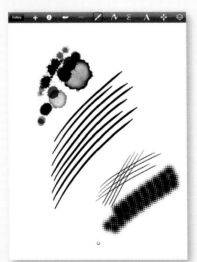

Shape/Fill Tool

Instead of using a brush tool, use a freeform shape tool to draw organic forms in the shape of a brush stroke. Rather than drawing the stroke itself, you essentially outline around it instead.

TUTORIAL: Designing a Character

In my day job as an illustrator, I draw a lot of pictures for children's books and comics. Character design is an essential part of my work.

While some of the limitations of the iPad may prevent me from making fully professional work on it, it is perfect for doodling ideas and concepts. I can carry it around like a sketchbook, create rough digital work, and import the results into my desktop software.

My most recent children's book is about monsters. Who doesn't love drawing monsters? I had to design a cast of about ten or so different monster characters. When I sit down to brainstorm ideas, I like to work as quickly as I can in order to get as many ideas out of my head as possible. When I get a few designs that I like, I will further refine them and figure out specific colors and details.

Here is an example of my character design process and how I use the iPad to brainstorm and finalize designs.

Adobe Ideas

For this tutorial, I have chosen the app Adobe Ideas. I have to admit, I was not a fan of Ideas when I first downloaded it because it lacks the amount of tools and brushes compared to other art apps. However, I eventually found that its beauty lies in its simplicity. It's quick and responsive, and what it does, it does well. It's great for doodling quick concepts. When you're done, you can export a PDF, resize the vector image to any size you want, and polish your finished piece with your desktop software.

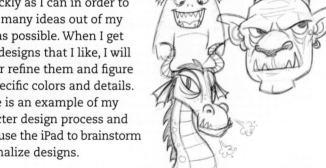

Getting to know Adobe Ideas

Toolbar

There is only one drawing tool with size, opacity, and color controls. There is also an eraser, and scroll/transform tools. That's about it; like I said previously, Adobe Ideas keeps things pretty simple.

Drawing

When you draw a stroke, Ideas will smooth the line for you. I found this to be quite handy, because it's difficult to get a steady line on the iPad. The app creates vector artwork, so it is resolution independent and you can zoom in as far as you want on your art without it becoming pixelated.

Layers

There is one photo layer and one draw layer. Tap the photo layer to import an image from your photo library. The photo layer is handy for adding sketches, reference, or background.

The draw layer is the layer you actually draw on. You can add up to ten layers, which are handy for inking and coloring.

Brainstorm

With the transform tool, drag with two fingers to move the layer; pinch to resize it; drag with three fingers to rotate.

1 Doodling
I lowered the size of my brush to around 2–3 pixels, and the opacity to 10–20%. I then started brainstorming monster ideas very quickly, keeping my sketches rough and loose.

2 Organize
I kept each doodle on its own layer. I did this so I could move and resize each sketch individually and organize them on the page.

Refine
Once I've brainstormed ideas, I can take a concept I really like and refine it a bit more.

3 Making a Duplicate File
To begin, I went back to the Ideas gallery by tapping on the Organize button at the top of the screen. Using the duplicate button, I made a copy of the file I was just drawing in.

4 Choosing a Sketch to Refine
In the new duplicated file, I deleted all the layers except the sketch I wanted to refine. I resized it and placed it near the center of my workspace. I then lowered the opacity and started a new layer for inking.

Import sketch

Alternately, you can save the sketch to your photo library, then import the sketch into a new file on a photo layer. (You may need to do this if you want to use a sketch from a separate app.)

TUTORIAL: Designing a Character

5 Inking

Using my iPad inking methods outlined previously, I started inking my sketch. In Adobe Ideas, I usually "outline" my lines using a smaller brush, then go back and color them in. I also use the eraser tool to refine stroke edges and points.

Outline using
a smaller brush

Color in
the lines

Finished
outline

6 Color

I will delve more into specific coloring techniques in later tutorials, but one great feature I like about Adobe Ideas is the ability to save color themes.

Save a Color

Once you create a color you like, tap and drag the swatch from the toolbar into one of the five main slots.

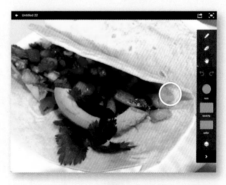

7 Saving Your Theme

Then tap and drag the entire set into your collection to save it.

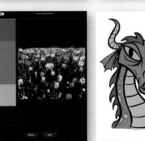

I like to pick colors from photos and create themes that I can use in my artwork.

Exporting Artwork

Ideas gives you two options for exporting work: email a PDF file or save a JPEG to your photo library. I recommend exporting the PDF if you intend to edit or resize the artwork, because it will retain the paths of the vector file. A JPEG will flatten and rasterize your image.

Desktop Editing

The PDF file can be opened in Adobe Illustrator. You can enlarge the image to any size, select and edit specific paths, adjust colors, or reorganize elements.

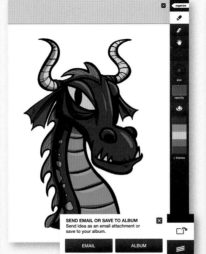

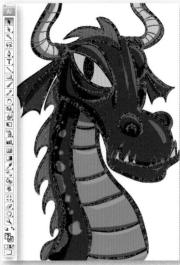

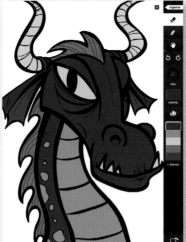
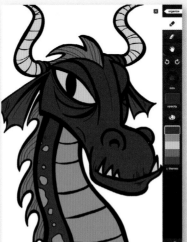

Exporting as a PDF retains all your paths, which are editable in Illustrator.

ARTIST SPOTLIGHT: Eric Merced

Eric Merced is a cartoonist based in Massachusetts. He has worked for clients such as Upperdeck, Marvel, IDW, and Zondervan. He works in everything from graphic novels to illustration. I especially enjoy his character designs and mascots. He frequently uses his iPad for sketching and creating characters, such as this "super" dog cartoon.

Eric also enjoys using the iPad for his work by doing research on the web, or using a portfolio app to show his work to clients. He has even used Apple's self-publishing software, iBooks Author, to create a digital art book that's available in the iBooks store.

Eric's advice for aspiring iPad artists is to "Stay loose . . . like with everything else in art, it's all a matter of getting used to it. And the more you practice, the more you'll get the hang of it, and the faster you will become."

Eric's tools and apps

Eric's Tools of choice
iPad 2, Wacom Bamboo stylus

Eric's Favorite Apps
Procreate, SketchBook Pro, Adobe Ideas, and Inkpad

"With sketches, I will stick to one app. Sometimes it's SketchBook Pro, and other times I use Procreate. If I am going to finish the illustration on the iPad, I will then pick the right app for it, which will either be Adobe Ideas or Inkpad."

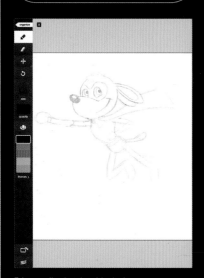

Eric usually sketches his designs in SketchBook Pro or Procreate.

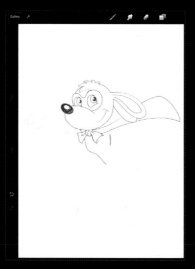

He uses Ideas to ink his drawings.

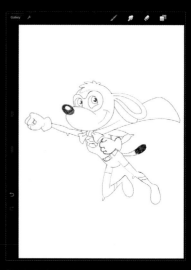

Finished ink drawing.

"I will often start projects on it. The fact that it's digital and portable makes it convenient to work on. I can, for example, continue working on a project at a doctor's visit while in the waiting room, and easily pick it up on my computer once I get back to the studio."

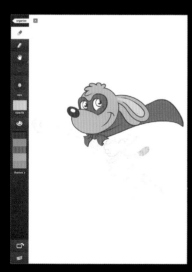

Using another layer, Eric adds color underneath his line.

"I use the iPad mainly as a sketchbook, but will sometimes create complete art on it."

PAINTING AND COLOR

I learned to draw on the computer while I was in college. It was a frustrating process. I could not get the same subtleties and texture that were in my acrylic and watercolor work. I had a tough time learning the software and getting used to a graphics tablet. But I kept at it because the potential was great, and it was fun to learn. Eventually, I got over it, and now the computer is my main tool in my illustration work. I still love my real paint sets, but the advantages of the computer are awesome and I'm glad I learned it.

I still love my real paint sets, but the advantages of the computer are awesome and I'm glad I learned it.

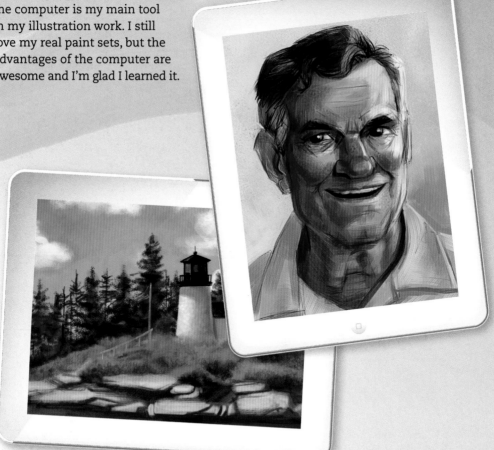

Years later, I picked up an iPad for the first time. It was a frustrating process. I couldn't get the same detail I could get with my Photoshop work, and I had to learn new software and tools all over again. But now I'm creating work on my iPad that I can proudly hold up next to my Photoshop illustrations and watercolor paintings. So when artists ask me why they should bother painting on this device, all I can say is, the potential is great and the advantages are fantastic.

Painting on the iPad is a unique experience. On one hand, you have many of the advantages of digital painting. You can use a variety of tools and apps on one device, and edit images on the fly. It is portable like a real media sketchbook, but more versatile. However, it falls short of desktop digital painting programs, which are far more powerful. On the iPad, you work with comparatively limited sets of tools, slower speeds, and lower resolution. It is neither a traditional sketchbook nor a full digital painting suite.

I think it's best to think of the iPad on its own terms. After all, if you take a set of watercolors and try to use them like oils, you will most likely be frustrated and disappointed; embrace the advantages and limitations of the medium, however, and you can create magnificent work. The same holds true when moving to the tablet. The device limitations are not as daunting if you think of them as jumping off points for rethinking your process.

When it comes to coloring on the iPad, you have to go back to basics—use bold colors and broad strokes, and work from general to specific shapes and lines. I enjoy the fact that the iPad encourages a return to these basic principles. They are all too often forgotten in the world of digital painting.

I seriously doubted I could create finished color work on the iPad when it first was released, but I am increasingly impressed with how far I can take a painting as I practice more with the device. Whether you're a gallery painter, illustrator, comic artist, pro, or hobbyist, I believe you will find tools that will work for you.

INTRODUCTION TO PAINTING ON THE IPAD

The iPad Vs. The Desktop

iPad apps won't have the expandability and editing options of a lot of desktop apps. In Photoshop, for example, you can quickly change colors and contrast on the fly. You can edit and move things around, mask layers, and add texture. You can also download and create your own brushes. Some iPad apps will have lightweight versions of these features, but they won't be nearly as powerful.

In some cases, you have to deal with the same limitations of real media—if you make a mistake on a piece of paper, you erase and start over. If you want to change a color on a canvas, you repaint it. The iPad is still more flexible than a piece of paper, but it takes some getting used to if you are adjusting from other digital programs. On the other hand, the simplicity of iPad apps can be refreshing.

Coloring Tips

Stay Loose

Given the iPad's limitations and lack of a fine-tipped stylus, I have found that I get most frustrated when I try to noodle out very specific details and exact lines. Stay as loose as possible for as long as possible. The iPad best utilizes big brushes and broad strokes. Zoom in as you progress in your painting, and the details will naturally emerge and become tighter.

Remember the details

This tip may sound like it contradicts my previous piece of advice, but the two really go hand in hand. Painting loosely doesn't mean you have free reign to scribble all over your canvas; it simply means you don't have to be pixel-perfect, but you still have to put some thought behind your brush strokes. Lots of "bad" iPad artwork I see is haphazard and, quite frankly, a mess.

That's not to say your painting won't be messy at times—virtually all iPad paintings begin this way. I paint very loosely for almost my entire process. It is only at the very end that I zoom in and add a few tight details to bring it all together. Lots of sub-par iPad artwork I see out there is missing that last level of attention to give it that extra polish.

Keep sketches loose

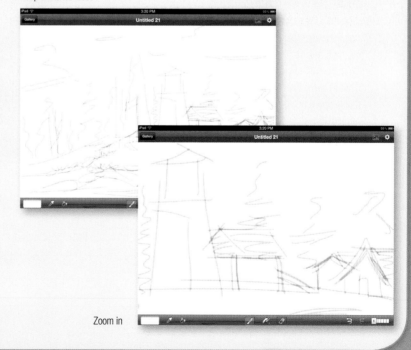

Zoom in

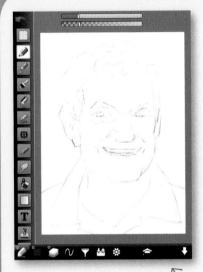

Picking Colors

All art apps will have the usual color wheel or swatch palette for picking colors. Here are a few other options that will help you out even more:

Eyedropper Tool

The eyedropper is always one of my most valuable tools while digitally painting. Use it to blend established colors on your canvas and move paint around.

Reference Photos

Some apps let you import reference photos. You can use the eyedropper tool to pick out colors directly. This takes the headache out of creating colors from scratch.

Color Themes

Some apps, such as Adobe Ideas, let you create your own color swatch collections based on a theme, or imported from a photo. This is a quick way to create a harmonious color theme for your painting.

Reference photos

Creating and Importing a Sketch

You can create a sketch from scratch using some of the drawing tips in the previous chapter, or you can import one from a scan or another app. Place the sketch on its own layer. Set the mode to multiply—you'll need an app like ArtStudio (above); this allows you to see through the "white paper" sections of the image, and helps it blend in with the rest of the painting better. Having the sketch on its own layer also gives you the flexibility to reduce the opacity or hide the sketch later.

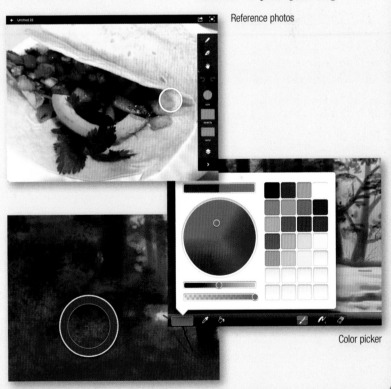

Color picker

Eyedropper tool

INTRODUCTION TO PAINTING ON THE IPAD

Blending Colors

Low Opacity Brushes
Set your brush to a low opacity and lightly paint on the edge of two colors. Use the eyedropper tool to continue to pick the mixed colors and smooth the edge.

Textured Brushes
Paint lightly on top of one color with another and let the base color show through the texture.

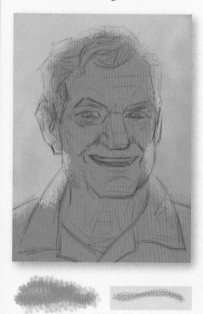

Spatter brushes

Smudge Tools
Some apps have their own smudge tool to blend colors together, and they can be useful when used selectively. I especially like the palette knife tool in ArtRage, which not only blends colors together but also retains and creates texture in the paint.

Palette knife to smudge and soften edges.

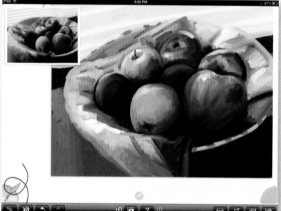

Layers
Layers are useful for quickly adding color overlays and adjustments. Simply lower the opacity or change the mode of the layer to blend the color with the rest of your painting.

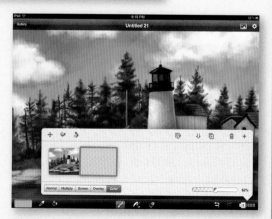

Use a new layer to add an overall wash over the entire illustration to subtly change its color.

Example Techniques

Layers

One simple way to color a drawing is to use layers to build up color, shadow, and effects.

First, create your sketch or line drawing and place it in its own layer. Place a new layer underneath and fill in some basic flat colors.

Create another layer and reduce the opacity to about 50%. Change the mode to multiply. Using black or another dark color, paint in your shadows.

Add another layer and reduce the opacity, and then set the mode to screen. Using white or another light color, paint in the highlights.

Layers are also useful for adding texture and other special effects. You can play around with layer blend modes and opacity to blend them in with your other layers.

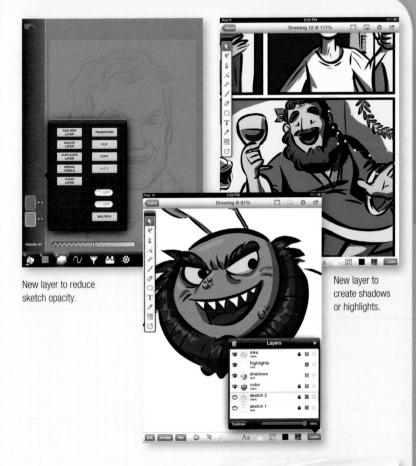

New layer to reduce sketch opacity.

New layer to create shadows or highlights.

Painterly Coloring

Most of my paintings require more than basic flat layers. I love to move colors around, blend them together, and create more textural work.

Block in basic colors with a high opacity brush. Use a light shade and dark shade of each color to establish light and shadow shapes. Keep it as simple as possible.

Blend the colors together and soften edges.

Gradually add more color and texture. Continue to zoom in to tighten up the painting.

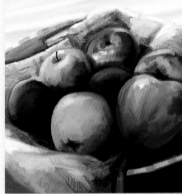

Blend colors for a more painterly effect.

TUTORIAL: Painting a Portrait

I love painting portraits! They are simple enough for quick studies, yet are challenging to get right and are great for drawing and painting practice. As in the previous chapter about drawing, I am going to use a portrait to share some tips about color.

To create a more realistic portrait and better capture the subtleties of color and texture in skin and hair, I used photo reference this time. This painting is based on a picture of my grandfather. He sure is a handsome guy, right?

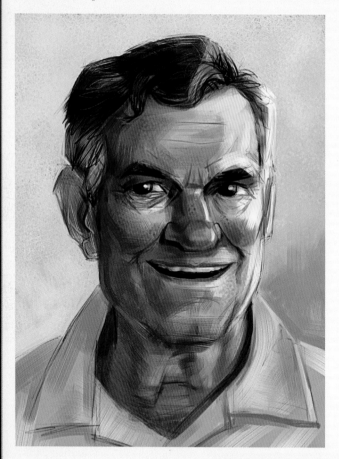

Tap the arrow in the corner to bring up the toolbars.

Introducing ArtStudio

The app I used is called ArtStudio. I had overlooked ArtStudio early on in favor of standard favorites like SketchBook Pro and Brushes, but it has an impressive amount of features tucked away in its interface. It's very versatile, and a solid all-around painting app if you are looking for a relatively inexpensive alternative to some of the heavy-hitters.

Tap and hold each tool to access the advanced options for each one.

Drawing tools, color picker, and layer palettes are along the bottom.

To start, I'm going to create a new layer so I can begin my drawing.

Drawing tools

Color picker Layer palettes

The Sketch

Using the pencil tool, I blocked in a rough sketch. I won't delve too much into this process since I already covered drawing tips in the previous chapter. If you have already done a sketch in another app, you can also import images from your photo library.

Background

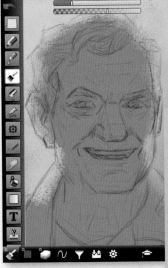

3 Painting a Background

When I'm painting, I like to work from back to front. First, I painted my background on a new layer underneath my sketch.

1 Choosing a Color to Sketch In

I chose to sketch in a reddish brown color because it will be integrated into the final painting later on. It looks a whole lot better than plain black.

2 Multiply

After I have a sketch, I set the layer mode to multiply, which helps it blend better. I then filled the layer underneath with a reddish brown color as a base.

4 Adding Texture

With simple backgrounds like this, I like to keep it interesting by adding texture. I used a scatter brush and let the brown color show through in places.

Tip

Play around with the brush settings to see what kinds of effects you can create.

TUTORIAL: Painting a Portrait

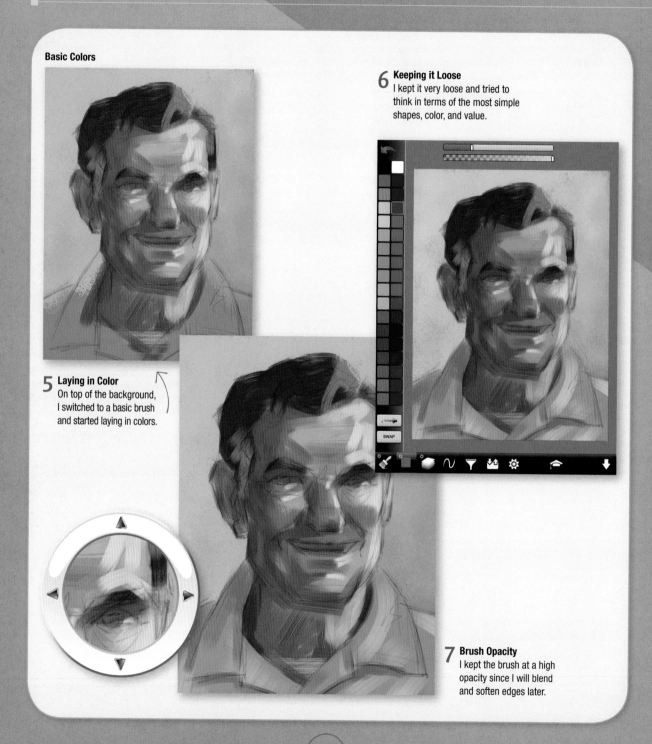

Basic Colors

6 Keeping it Loose
I kept it very loose and tried to think in terms of the most simple shapes, color, and value.

5 Laying in Color
On top of the background, I switched to a basic brush and started laying in colors.

7 Brush Opacity
I kept the brush at a high opacity since I will blend and soften edges later.

Blending and Refining

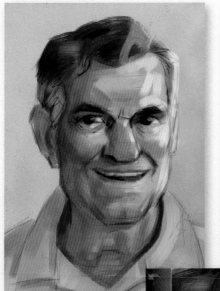

Details

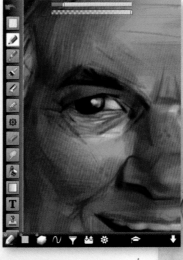

10 Sharper Details
Near the end of the painting, I used a very small brush at a high opacity to get some of the sharper details, such as the eyes, hair, and various lines and wrinkles about the face.

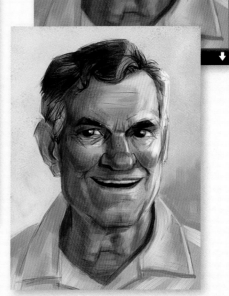

8 Refining the Painting
As I refined the painting more and no longer needed the drawing for reference, I started a new layer and placed it on top of my sketch. I then proceeded to clean up messy lines and render more detail. Using low opacity brushes, I blended the colors and built up paint.

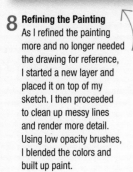

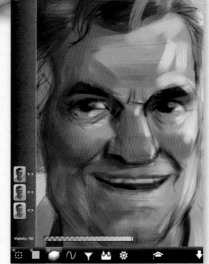

9 Using Different Textures
I used different brushes for textures and effects. For example, I used a splatter brush to lightly add freckles and spots to the skin.

Final image

ARTIST SPOTLIGHT: Marc Scheff

Marc Scheff is an illustrator and designer who does great conceptual work and portraits. I was impressed when I came across the life drawings he created on his iPad.

Marc loves to paint figures on his iPad. It works great for jotting down quick visual ideas for his paintings. He says:

"It is different than the usual large pad of newsprint or sketchbook. It forces me to think about fundamentals."

" . . . There's no more magic to pixels than there is to paint . . . "

He uses a lot of his traditional painting skills to inform his iPad painting technique.

"I use the same process as I would with charcoal or oil. I use a bigger brush, opacity set to about 20% to block in big shapes. Then I use smaller and smaller brushes, with the opacity set to more and more opaque. If I'm doing something fast, I might use a brush at full opacity for a five-minute alla prima. For longer poses, I do an underdrawing with a small brush and use that as the structure for the painting."

In addition to painting on his iPad, Marc also uses it as his main portfolio.

"I love the versatility and speed with which I can update albums. And if I want to show off work to two art directors, I can create albums on the fly tailored just for them."

To new iPad artists, Marc recommends:

"Treat it like any other new medium! Experiment with new textures. Refresh yourself on your own process. There's no more magic to pixels than there is to paint. If you can create a great drawing, the work will stand up."

Marc's tools and apps

Marc's Tools of Choice
The new third-generation iPad and his fingers!

Marc's Favorite Apps
Brushes

Where to find Marc's work:

For more of Marc's work, visit his website at

www.marcscheff.com

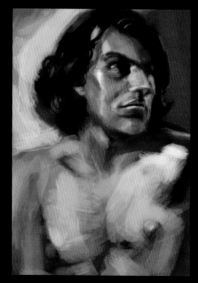

Jeremiah

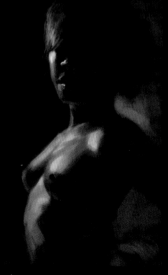

Kimberly

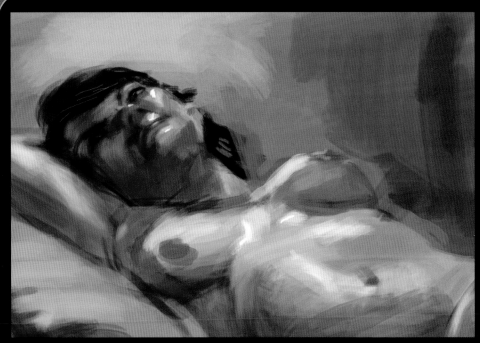

Chana

"I love the versatility and speed with which I can update albums . . ."

"Treat it like any other new medium! Experiment with new textures . . ."

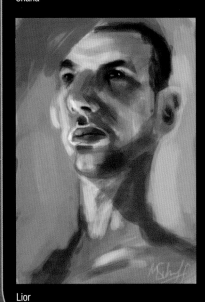

Lior

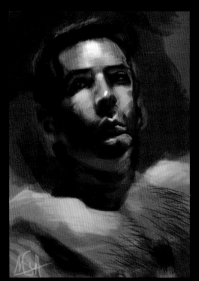

Tom

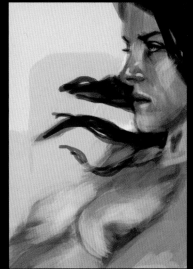

Francis

TUTORIAL: Painting a Still Life

In my day job as an illustrator, I typically work on my computer in Photoshop all day. Sometimes, I just want to break out my paints and go to town! That's why I love the app ArtRage. It is built to work just like real paint, with textures, blending, and tools that are meant to emulate the real thing. I love carrying my iPad around and using ArtRage for quick studies.

For this image, I wanted to create a traditionally inspired still life, harkening back to skills I used in oil painting class in school. One thing I love about the iPad is that setup is quick! There are no big easels to put together, or mess to clean up afterwards. I'll miss the smell of turpentine though. Well, not really.

No need to break out the messy oil paints! For quick sketches and studies like this still life, I like to use ArtRage on my iPad to simulate a real media painting experience.

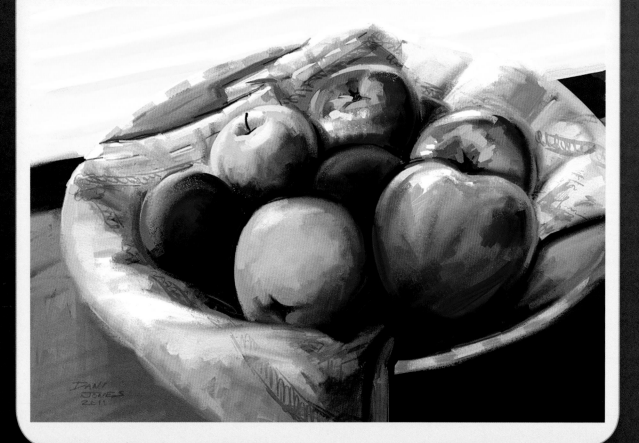

Original

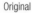

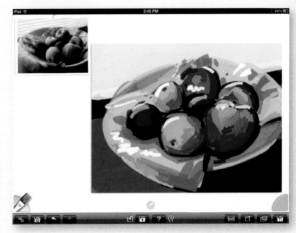

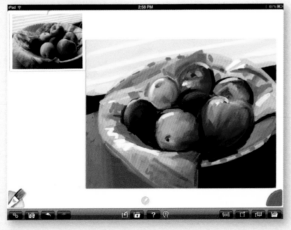

2 Blocking In

I did not use a sketch, but went straight to color, working with broad shapes rather than a line drawing. My brush strokes at this stage are very messy and bold.

One thing to remember

One thing to remember about ArtRage is that paint will "build up" and blend together just like real paint. If you start with too much paint right away, you might end up with a muddy mess, or too much texture. To block-in a painting, I usually change my brush settings by raising the amount of thinner.

1 Reference

Tap the reference button at the bottom right of the ArtRage window to import an image from your photo library. You can resize and reposition the photo on your board to your liking by pinching or dragging on it with two fingers.

3 Keep Colors Fresh

If you have trouble with colors blending too much, start a new layer. Colors don't blend across layers, so you can start fresh.

You can also use the Insta-Dry and Auto Clean settings. Insta-Dry will prevent your brush strokes from blending into any of the other colors on the canvas. Auto Clean "cleans" your brush with every stroke. If this is turned off, the brush will keep the color it picks up as it blends paint together, just as a paintbrush would pick up wet paint on a real canvas. Turn this on to keep your brush color fresh with each new stroke.

TUTORIAL: Painting a Still Life

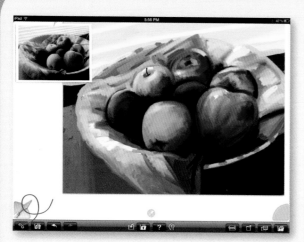

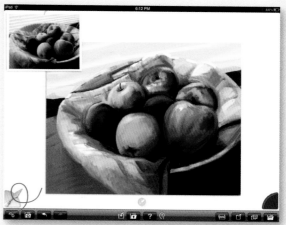

4 **Blend**
Using the palette knife tool, I blended the bold colors together and softened a lot of the edges.

5 **My Painting Process**
Most of my painting process from here on out would be a back and forth of laying paint down, and blending with the palette knife.

Use a dry brush or palette knife to further blend colors together.

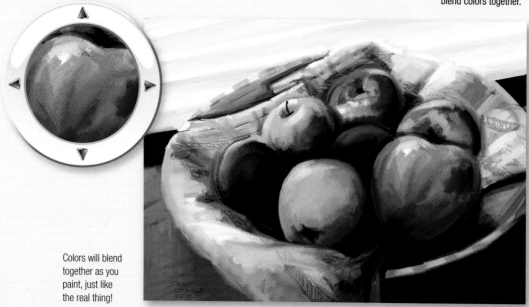

Colors will blend together as you paint, just like the real thing!

6 Building Up

As the painting progressed, I increased the pressure of the brush, and decreased the thinner. This gave me thicker paint that I could move around and blend. I gradually built up stronger strokes and details.

7 Details

On a new layer, I used a small round brush to draw the pattern on the cloth. I decreased the opacity of the layer to help it blend better.

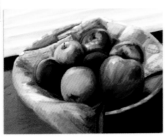

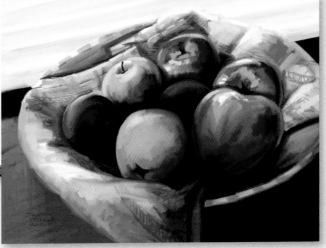

8 Small Details

For the apple stems and other small details, I used the pencil tool.

Final image

The photo that inspired this painting comes from a trip I took to Maine last summer with my family. I love the bright color and the variety of textures in the sky, rocks, trees, water, and architecture.

Unlike with my portrait and still life tutorials, for this painting I did a lot more experimenting with brush tools and texture. Landscapes lend themselves well to this type of experimentation.

I chose to use the app Brushes for this painting, in order to show the variety of texture you can achieve even with a simple brush set. Compared to other apps like SketchBook Pro and ArtRage, which have many different tools with all kinds of settings to play with, Brushes is limited in my opinion. However, that doesn't mean you can't get great effects with the app. Too many tools or complicated settings can be confusing. I like the simplicity and easy interface of Brushes.

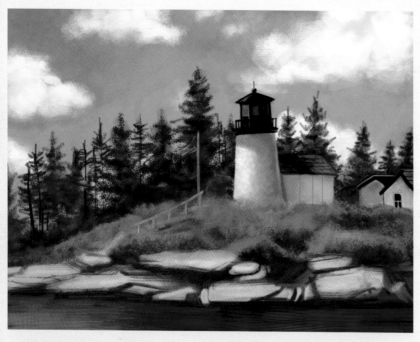

For this painting, I used different types of brushes to achieve the different textures in the sky, trees, grass, rocks, and buildings.

Brush Basics
By default, you can double-tap to zoom in or out. I personally don't like this feature because I paint with a lot of quick, short strokes and keep activating it accidentally. To turn it off, you have to exit out of Brushes and go to the iPad Settings app.

To get around the app, tap once anywhere to hide the toolbars, or bring them back again. The color, brush, and layer tools are along the bottom.

Gallery button

The Gallery button at the top left brings you back to the gallery page and also saves your painting.

Color

Brush

Layer tools

Brush Settings

The brush options can be accessed in the center of your bottom toolbar. Tap either the brush or the eraser, then tap the center button to change its settings.

There are approximately 20 brushes to choose from. You can change the spacing, size, and opacity. You can also choose to vary the size or opacity by the speed of your strokes.

Here are some of the specific kinds of brushes I used for this painting. I will refer to them throughout the tutorial.

Bristle brush
Basic coloring brush.

Hatching and cross-hatching brushes
Line brushes, good for adding quick crisscrossing texture.

Spatter brushes
Create a spotty texture, like a spray can or splattered paint.

Pastel brush
A textured brush that draws like a chalk or crayon.

1 Rough Sketch
Using a small brush at a low opacity, I made a rough sketch. I didn't get too detailed though.

This is mainly for blocking out my composition. When finished, I lowered the opacity and filled the layer underneath with a yellowish brown base color.

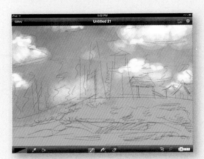

2 Sky
Starting with the sky, I used a basic bristle brush to block in colors.

I began with a dark blue and built up light colors on top at a low opacity.

I like the watercolor effect this creates, and it's a good way to make nice feathery clouds.

TUTORIAL: Painting a Landscape

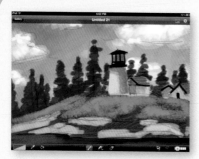

3 Foreground
On top of the sky, I began blocking in the shapes in the foreground. Again, I worked with dark colors first, then built up lights on top.

4 The Grass Area
In the grass area, I used a spatter brush, which made a good foundation for the texture of the grass. I changed the size and spacing periodically to give it more variety and prevent the texture from looking too monotonous.

Throw out the sketch

At this point, I didn't need my sketch layer anymore. You can hide it by sliding the opacity slider all the way down in the layers palette. You can always bring the sketch back later if you need it for reference.

5 Softening the Edges
With my painting blocked in, I went back and softened the edges in the sky and the trees using a crosshatching brush. It made a nice feathery effect.

Details

6 Tree Detail
Using the same spatter brush that I used for the grass, I went back and painted the branches on the trees. I built up light greens on top of the dark shapes to give the trees dimension. I also added some tree trunks here and there with a line brush.

8 Grass Detail

For the grass, I used a combination of pastel and hatching brushes.

9 Rocks and Water Detail

For the rocks and water, I painted the basic light and dark shapes with a bristle brush, then went over them lightly with hatching brushes to soften the edges and give them texture.

7 Building Detail

Working my way forward, I rendered the lighthouse and other buildings. A spatter brush worked well for the bumpy texture on the lighthouse wall. To get the fine details on the buildings, I zoomed in quite a bit to help with accuracy.

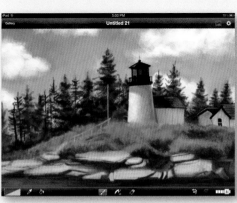

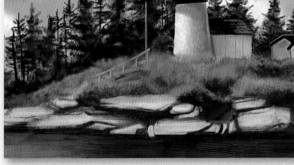

Final image

ARTIST SPOTLIGHT: Fraser Scarfe

Fraser Scarfe is a fine artist based in England, specializing in landscapes. He currently exhibits with galleries in Lincoln and London, and his work is held in private collections throughout the U.K. and Europe.

In his landscapes, Fraser attempts to capture the beauty and drama of his subject matter to convey the actual experience of being in the place. He says, "It seems to me that the best painters are those who, with integrity and succinctness, use a few marks but reveal a truth and beauty in a subject that people would never have seen otherwise." This is certainly true of his iPad art. He turns the iPad's limitations into strengths and creates some stunning work with simple strokes and color.

"I think the most successful iPad art is that which explores the iPad as a medium in its own right, rather than trying to mimic the look and effects of actual paint."

Fraser mostly makes quick, economic studies with the iPad on location. He also uses it for photography and keeping visual diaries. "The immediacy and boldness of the marks make for very exciting images," he remarks.

Fraser's tools and apps

Fraser's Tools of Choice
iPad 2 and a stylus

Fraser's Favorite Apps
Brushes, ArtRage

"For larger works, I tend to work more slowly and methodically, building the image gradually using layers of color."

Sky study

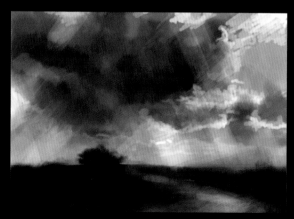
Sky study

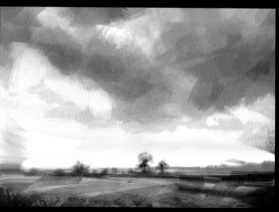
Edlington

Fraser thinks there is a bright future for iPad artists. "Making art on the iPad is seen by many as a gimmick or fad—I totally disagree with this. The medium is incredibly practical and exciting to use and I think a revolution in digital art is about to occur." I couldn't agree more.

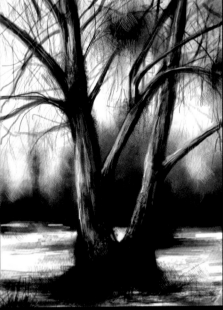

Trees study

Trees at Edlington, early stage

> " . . . The medium is incredibly practical and exciting to use and I think a revolution in digital art is about to occur."

Trees at Edlington, middle stage

Trees at Edlington, finished

Where to find Fraser's work:

Check out more of Fraser's work on his website at

www.fraserscarfe.co.uk

LAYERING AND EFFECTS

A great tool to utilize while coloring is layers. Almost all art apps have layer capability. You can use them to keep color separate or apply special effects quickly and easily.

When to Use Layers

To separate the processes, I almost always keep my sketch, line drawing, and colors separate. Drawing on the iPad can be a messy business, so learn to use layers to hide your early roughs.

To Add Shadows/Highlights

Layers make shadows and highlights a snap because you can add them without ruining your coloring work. You can adjust them as needed so that they look just right. Lower the opacity or change the blend mode to help them blend into the colors beneath.

Layer Modes

Layer modes affect how the layer blends with the ones beneath it. They are useful for mixing colors more effectively and subtly. Some basic layer modes are:

To Adjust Color

I often use layers to add subtle color gradients or an overall wash over the entire illustration.

Normal
The default layer mode.

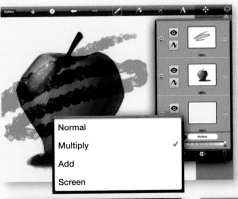

Advanced apps

Advanced apps will have other modes like Color, Hard Light, Soft Light, etc. They are fun to experiment with to see what kind of effects they can create.

Screen

This is sort of like the opposite of Multiply. It will lighten the layers beneath it, and is good to use for adding highlights or lighting effects.

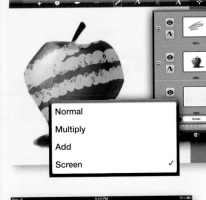

Multiply

This mode blends with and darkens the layers beneath it. It is great to use for shadows. Because this mode essentially makes all the whites on the layer transparent, this is also a good mode to use for imported sketches so you can see through the "paper" of your drawing, and color beneath it.

Overlay

Use this mode to blend the layer with those beneath it. It is more subtle than Multiply and Screen, and doesn't darken or lighten per se. This mode is good for washing colors over other layers.

Other Layer Settings: Opacity

This changes how transparent the layer is overall. Lower the layer's opacity to lessen the effect of a layer, for example to lighten shadows.

TUTORIAL: Creating Comic Art

A comic is a great way to showcase the abilities of layers because a comic page is often done in stages, such as pencils, inks, and colors. You can turn your iPad into your own comic production powerhouse!

For this tutorial, I've chosen to use the app Inkpad. It is a vector drawing app similar to Adobe Illustrator. With vector art, you can scale your images to any size without pixelation, which is important for the crisp linework that is common in comics. Inkpad's path tools are also handy for creating panel borders, speech bubbles, and text, all of which is why it is my comic app of choice.

This comic features a scene from one of my favorite stories, Charles Dickens' classic A Christmas Carol. Inkpad is perfect for inking, coloring, and lettering comics pages.

3 Importing the Sketch to Inkpad

I then opened Inkpad and imported the sketch onto its own layer, lowered the opacity, and locked the layer. I was now ready to ink!

1 Page Template

Comic pages often have to be made at uniform sizes, so I find it handy to use a template. I created a basic guide in Photoshop on my computer, then imported it from my photo library to my sketching app of choice.

2 Saving the Sketch

After I finished my sketch, I saved it to my photo library.

4 Panel Borders

For my panel borders, I used the rectangle tool. At the bottom of the screen, I changed the fill color to none and the stroke color to black, and changed the stroke thickness to about four to five pixels.

I could draw each panel individually, but it would be hard to keep the panels aligned. So instead, I like to start off by creating one large rectangle that encompasses the entire page.

TUTORIAL: Creating Comic Art

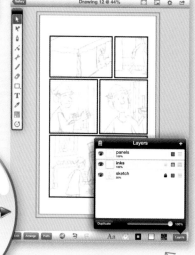

5 Breaking Panels

Next, I drew a couple of smaller rectangles where the horizontal breaks should be. Then I used the selection tool to select all the shapes, and tapped the Path menu at the bottom of the screen.

6 Subtract

I then chose Subtract Front to cut out the horizontal breaks from the large rectangle. This creates three horizontal panels on the page. I repeated this process for the vertical breaks to complete my panels.

7 Creating a Shield

I finished by creating one large rectangle over the entire page, running completely over the edges of the document. I changed the stroke color to none and the fill color to white, then tapped the Arrange menu and sent this rectangle to the back of the layer. I could now see the panel borders, but the sketch was still hidden.

8 Punching Out the Panels

I then selected everything and went back to the Path menu and chose Subtract Front again. This punches holes in the white rectangle where the panels should be. I created a new layer for my inks between my sketch and panel layers. The panel shape will effectively hide everything outside of the panels, so I could now draw underneath the panel layer and not worry about going outside of the panel borders!

Fixing stray marks

You can use the eraser to fix stray marks. If you select a path first, it will only erase that specific path.

10 How to Ink
You can try some of the inking tips I mentioned in the Drawing chapter. In Inkpad, I prefer to use the method of drawing my inks by going around the outline of each stroke. In other words, I draw the SHAPE of the stroke, not the LINE. I used the brush tool and changed the stroke color to none and fill color to black, and proceeded to draw my strokes in this way.

9 Inking
Inking in Inkpad is going to be different than your typical inking process because there is no pressure sensitivity and you can't draw thick-to-thin lines.

TUTORIAL: Creating Comic Art

11 Flats
When I finished my inks, I started a new layer underneath for my colors. I used the brush tool again, but this time changing the fill color as needed. I put down basic flat colors.

12 Shadows
Starting a new layer over my colors, I changed my fill color to black to draw my shadows. I lowered the opacity of the layer to about 50% so they would blend with my colors.

14 Word Balloons

Using the circle tool, I drew white ovals for my speech bubbles. I added tails using the pen tool. Select both shapes and go to Path > Unite to create a single shape.

13 Special Effects

For the candles, I created a new layer above my inks. Over each flame, I drew a circle shape and changed the fill to Gradient. I used the radial setting in the bottom left of the fill options panel and changed the inside color (left side) to light yellow, and kept the outside color (right side) transparent to create a glow effect. I lowered the opacity of the entire layer slightly to 80% to make the effect more subtle.

15 Adding Text

Then, I used the text tool to type out my dialog. You can change the font, size, and alignment by tapping the letter icon at the bottom of the screen.

Final image

ARTIST SPOTLIGHT: Reed Bond

Reed Bond is a graduate of Ringling College of Art and Design, and is influenced by 50s and 60s advertising art. I first came across his iPad work through a bunch of character designs he posted on his blog. I love how even on the iPad, Reed is able to maintain organic lines and texture in his work. It is incredibly whimsical and fun.

Reed loves drawing comics and commissions with his iPad. He finds it handy for creating quick work for his blog, or updating his website. He keeps all his portfolio images on his iPad to show to potential clients or commissioners.

Describing his sketching process, Reed says, "I use a semi-opaque brush to rough out the composition and poses. Then on another layer I draw

"SAVE OFTEN! I can't stress that enough. Just like with any computer the iPad can crash and work can be lost . . . "

over the shapes with rough detail. I keep repeating this process until I'm happy. Then I draw line work, color, and texture."

Reed also has a good tip for iPad newbies: "SAVE OFTEN! I can't stress that enough. Just like with any computer the iPad can crash and work can be lost. Save before doing anything major like merging a layer or filling a complex shape."

But just like with his artwork, Reed sees the positive in the situation. "One time I had worked on an entire illustration that I was fairly pleased with and the app crashed. I was

Where to find Reed's work

Learn more about Reed and check out his artwork on his website at www.reedbond.com

He also posts many of his iPad sketches on the group illustration blog Drawed Goods http://drawedgoods.tumblr.com

reverted back to my sketch and I was devastated. But in redrawing I found that I actually improved the image. So even though I say 'save often,' sometimes crashes can produce happy results."

Reed's tools and apps

Reed's Tools of Choice
First-gen iPad and a Wacom Bamboo iPad stylus

Reeds's Favorite Apps
SketchBook Pro

"I use a semi-opaque brush to rough out the composition and poses. Then on another layer I draw over the shapes with rough detail. I keep repeating this process until I'm happy. Then I draw line work, color, and texture."

ADVANCED TECHNIQUES

■■■■

Once you've got the basic iPad drawing skills down, the next challenge is to bring more depth and interest to your paintings, and start creating more complex work. When I bought my iPad, one of my goals was to put it through its paces and see just how far I could integrate the iPad into my professional process. Could

I create paintings that looked just as good as the rest of my portfolio work? Would I be able to make images worthy of sending to clients? Could I really create complex illustrations on such a lightweight device?

When I bought my iPad, one of my goals was to put it through its paces and see just how far I could integrate the iPad into my professional process.

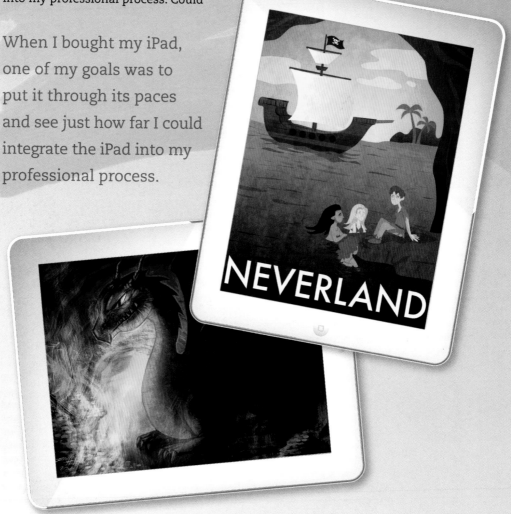

The answer to all those questions was an emphatic YES. I had some challenges, and there are still issues that need to be worked out, but for the most part I've been able to bring my work up to par with the art I create on my desktop.

Once you get used to the iPad process, that's when it starts to get fun. You can use multiple apps and work them together for different purposes; you can make your own brushes and texture for more variety; and as you further practice your drawing skills on the iPad, you can create more complex compositions and themes.

Once you get used to the iPad process, that's when it starts to get fun. You can use multiple apps and work them together for different purposes . . .

CREATING AND USING TEXTURE

One of the best ways to instantly add interest to your iPad artwork is texture. Texture can quickly turn an OK painting into a great one. It gets rid of the blandness that is usually prevalent in bad digital art and can really take your iPad paintings to the next level.

Creating Texture

Photos

If your iPad has a camera, you've already got one of the best tools for creating a good texture. I love incorporating natural elements into a painting. They bring a subtlety that's hard to reproduce by hand. My favorite sources for texture are tree bark, leaves, stone, and run-down buildings. You could literally look anywhere and find something.

Textured Brushes

A lot of the iPad apps have a great collection of brushes. Experiment with as many as you can and use multiple brushes for your painting. Use brushes at low opacity and build colors on top of one another. Use different textured brushes and change the settings around for different effects, letting base colors show through the top colors in places.

Photographic background

Painted background

Photographic background

Using Texture

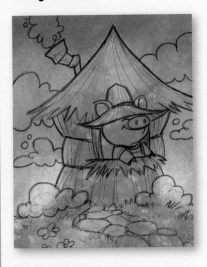

Brushes

Some apps let you incorporate textures into your brushes. The Procreate app, for example, lets you integrate texture into both the shape and grain of the brush to make your own custom painting tool.

Base Layer

I will often begin a painting with a textured background to create visual interest right from the start. I paint over most of it by the end, but bits and pieces show through and add interest.

Overlay

A quick way to add texture is to simply lay it on top on its own layer. You can use layer modes like multiply, hard light, overlay, or color burn to make it blend with different effects. You can also lower the opacity to make the texture very subtle.

Overlay before

Overlay after

TUTORIAL: Creating a Children's Illustration

Painting a Fairy Tale

I work mainly as an illustrator for kids' books, so I have a special place in my heart for children's illustration. Funny characters, whimsical stories, and charming settings are among my favorite things to draw. Is it possible to create such work on an iPad?

The illustrations you find in children's picture books are sophisticated, textural, and full of character. It can be quite a task to capture those qualities on a simple "fingerpainting" device. However, it struck me as a fun challenge and I was keen to find out how far I could take my illustration work on the iPad.

In my day-to-day work, I tend to make images that are bright and textural with a pastel-like quality. To accomplish this on the iPad, I utilized lots of layers and a variety of brushes to slowly build up colors and details.

For this tutorial, here is an illustration I drew influenced by a classic fairy tale.

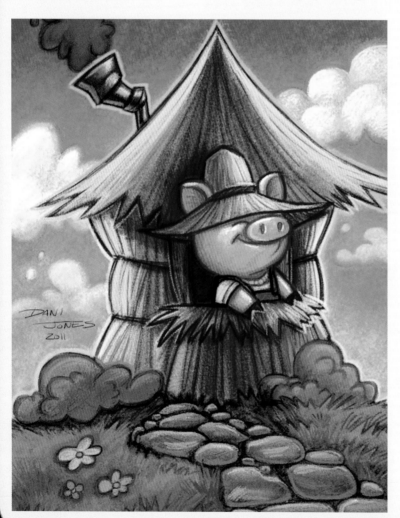

Final Image

Here is a finished illustration I created on my iPad. I was able to produce the same kind of texture and color effects I use in my children's book illustrations. With some practice, I have been able to create work on my iPad that I would proudly display with any other of my artwork.

1 The Sketch

You will need to start your illustration with a sketch. You can draw one (see some of my earlier tutorials for drawing tips) or import an image from your photo library. I started with a simple line drawing created directly in SketchBook Pro.

Place your line on its own layer. I like to set the sketch layer to multiply and lower the opacity slightly (somewhere between 50–80% should do). That way, it will blend with the colors better later on.

2 Base Layer

Create a new layer and place it underneath your sketch layer.

I like to begin my paintings by covering the entire canvas with a neutral color and a little bit of texture. By the end of the painting this layer will be mostly covered up, but I think this helps create a little visual interest, while also giving me a base color to start from instead of the stark white background.

Skimming through SketchBook Pro's selection of brushes, I picked a splotchy watercolor-like brush and set it to a low opacity. I gradually built up a nice texture using some shades of brown.

Covering the canvas

You can also change the color of the line if you prefer. For this painting, I locked the opacity of the sketch layer and went over the entire layer with a dark brown color.

TUTORIAL: Creating a Children's Illustration

4 Foreground

I added another layer on top of my sky layer. This is for my foreground elements such as the house. This let me paint these objects without ruining the background and gave me the ability to easily go back and paint more of the sky if I wanted to.

Working my way from the background to the foreground, I continued to block in large areas of color very quickly and roughly using large brushes.

3 Background

Create a new layer above your base layer, but still underneath your sketch layer. This is where I start adding actual colors to my illustration.

I switched my brush to a more chalky pastel-like brush. I like to build up my colors gradually, so I prefer to use a brush with a lot of texture.

Start with your background elements first. I started by painting the sky.

With a low-opacity brush, I painted some lighter blues on top of my first pass, giving the illusion of light radiating from the horizon. I also painted the white clouds in the sky.

Note

SketchBook Pro only supports up to six layers. If you find that you need more, you will have to start merging some layers together. If you want to add more layers, but also want to keep the ability to go back to a previous version of your painting that had the old layers, SketchBook Pro provides a "Save A Copy" option to quickly save a duplicate of your painting.

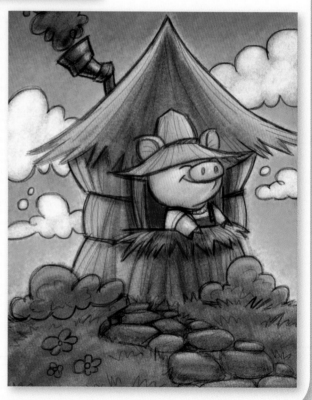

6 Details
Reduce the size and raise the opacity of your brush and start adding more precise brush strokes.

5 Refine and Build
While painting on the iPad, you are constantly wrestling with precision. However, I find it easiest to have fun working loosely and roughly for as far into a painting as possible. Take advantage of the iPad's simple nature. Use big, broad strokes. Experiment with different brushes and textures. Focus on adding large areas of darks and lights. Details will naturally build up and will be easier to render.

Once you've got quite a bit of color added to your painting, take advantage of the eyedropper tool to select colors. Blend the colors with a low-opacity brush.

If you find you need to adjust the value, texture, or color of your painting, try utilizing layers. Paint on a new layer on top of your current one. Reduce the opacity or change the mode of the layer (multiply, for example, is great for shadows) to blend it into the rest of your painting. You can then merge it into your working layer to continue painting normally.

7 Clean Up
When your colors are well blocked-in, add a layer on top of your sketch layer and add even more details and clean up messy lines. I also use this layer to add my strongest highlights and shadows to give the image a little bit more punch.

8 When you have made your final adjustments, save your image and you're done!

ARTIST SPOTLIGHT: Will Terry

Will Terry is a prolific artist and children's book illustrator. In the last ten years, he's illustrated more than 25 children's books for Random House, Scholastic, Simon & Schuster, and Dial, among others. His work has appeared in national advertisements for Sprint, Pizza Hut, M&M Mars, Pepsi, and Fed Ex, and in publications such as Time, Money, and the Wall Street Journal. He has also illustrated board games, educational books, and is currently developing his own digital books and iPad apps. Whew!

I love Will's work. It is bright and colorful and imaginative. And if his body of work wasn't enough, he is a generous teacher and mentor as well. He is a university instructor and recently co-founded the new company FolioAcademy. com, which provides online streaming art tutorial videos (including ones about painting on the iPad!).

About the iPad and his art, Will says:

"I've replaced my sketchbook and exclusively complete all of my drawings in the Brushes program. I like this tool because you never run out of drawing room like you do with a traditional sketchbook. If you need more space you simply 'resize' your drawing—move it over and keep working. I complete all of my drawings on the iPad and then email them to my desktop where I finish them in Photoshop."

Will also uses his iPad in his work as a calendar, day planner, web browser, and social connection tool. He takes notes and collects cool storybook apps. Additionally, he uses his iPad to give presentations at elementary schools and colleges.

> **Will's tools and apps**
>
> **Will's Tools of Choice**
> iPad 2 and his finger
>
> **Will's Favorite Apps**
> Brushes and ArtRage

"I've replaced my sketchbook and exclusively complete all of my drawings in the Brushes program..."

"Cold"

"Mountain Town"

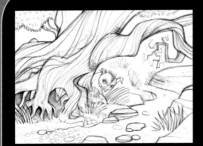

Goblin, sketch

Goblin, in-progress

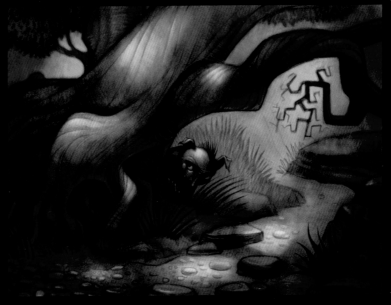

Goblin, finished

When drawing on the iPad, Will recommends making use of the zoom tool. "In order to make detailed drawings you need to use the zoom feature as much as possible to perfect lines and add details. If you work at 100% you will probably be frustrated that you can't recreate your vision."

Will usually starts his drawings in light gray at a low opacity. As he builds up the sketch, he'll go darker and darker, using more layers for refinement.

"Probably the biggest tip I can give is to learn how to resize your drawing so you never run

" . . . I complete all of my drawings on the iPad and then email them to my desktop where I finish them in Photoshop."

out of image area," Will advises. "This feature to me is really what makes drawing on an iPad more valuable than working traditionally—the ability to touch a tool and then pinch and reduce, and move your drawing up, down, or sideways, giving you more room to keep drawing."

And as a last word of advice, Will offers, "Find a drawing program you like and then stick with it. It will help your work flow to be able to know the controls so well that moving about the program becomes effortless."

Where to find Will's work

You can see more of Will's awesome work at

http://willterry.com

CREATING BRUSHES IN PROCREATE

In this section, I'm going to highlight one specific app called Procreate. It is high up on my list of painting apps due to one particular feature—the brush engine.

Procreate is the only app I've come across so far that allows you to make your own brushes. Lots of other apps will provide a great variety of brushes, and will let you change many of the settings, but Procreate is the first app I've seen that will let you start from scratch. It's incredibly useful for creating specific effects and realistic textures.

The Basics

To create a brush in Procreate, you need two things—a shape, and a grain.

The shape defines your brush tip. This affects what your stroke looks like when you draw it. A basic round circle will give you a typical line. A square will also give you a line, but with chiseled edges. An organic shape with lots of open spaces will look like a bristle brush.

The grain is the texture of the brush. This gives it the effect of painting on a textured surface. You can apply a canvas texture, paper texture, or even, if you like, a pattern.

The shape and the grain together create a unique brush, and, as you can imagine, you can get an infinite amount of variety and effects by using different combinations of shapes and grains. (And I haven't even mentioned the rest of the settings yet!)

Both the shape and the grain are defined using black and white images. Anything white is translated as opaque, and anything black is read as transparent. Grays are somewhere in between.

Brush settings panel in Procreate

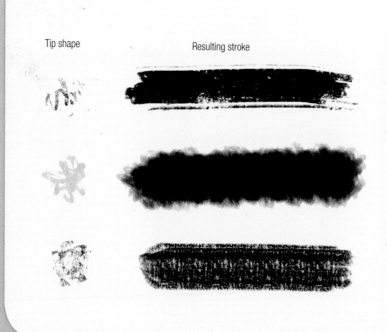

Tip shape

Resulting stroke

How to Make Brush Shapes and Grains

Specifications

You can use any size image you want, but keep in mind that Procreate turns your brush shapes and grains into a 1024 x 1024-pixel image when you import them. If you can, create your brushes at this size. They should also be in grayscale mode. Any color information will be discarded.

Making Shapes and Textures

There are several ways to go about creating brush shapes and grains:

Draw it

This is simple, and you can do it right on your iPad in any app you want. Simply create a drawing or scribble and save it to your photo library to import into Procreate. I suggest drawing with white on top of a black background. Otherwise, you'll have to invert it before using it as a brush.

Scan it

The best way to create realistic painting brushes is to use real paint! I like to use ink, pencil, and paint to draw random splotches and spatters. I then scan them and use Photoshop to convert the images to black and white, adjust the levels, and invert them. I sync the images to my iPad and bring them into Procreate.

Sketchbook brush strokes

1 Ink splotch

2 Ink brush

3 Scribbled lines

4 Watercolor splotch

CREATING BRUSHES IN PROCREATE

Open the image in Photoshop. Convert it to grayscale and crop to a square. Go to Filter > Other

Take a Photo
Of course, you can use any photo on your iPad. They usually don't work well for the brush shape because they're all basically rectangles, but they work well for the grain. I like to take photos of natural elements like tree bark and stone for the best texture.

Repeating Grain Textures
When you apply a grain to a brush, you may notice that you can see the edges of your texture image because it repeats across the page. The best way to get rid of those is to use a seamless texture. Procreate provides some great ones already with the app, but if you want to make your own, you need some Photoshop trickery.

> Offset and move the sliders so you can see the edges of the texture.

Spacing close together

Spacing far apart

Scattering

Paint settings

Use the clone, patch, or other Photoshop tools to clean up the edges so that they fit together.

You should now have a square tile that will repeat seamlessly! Remember to adjust the contrast and invert the image if need be before taking it into Procreate.

Other Brush Settings

Once you have your shape and grain defined, Procreate provides a whole bunch of other settings to create even more variation in your brush. Here's a brief explanation of what you'll find.

Spacing and Scattering

Spacing affects how far apart the brush shapes are along the stroke. Close together, it draws as a clean line. Far apart, it plots each shape along the stroke like a dotted line. Scattering will offset the brush shape from the center line of the stroke.

Size and Opacity

You can set each stroke to taper automatically at the beginning or end of your stroke. You can also set the dynamics, which will change the size and/or opacity depending on the speed of the stroke. If you want to limit the size or opacity of your brush—to make a small pencil that draws very lightly, for example—you can do that too.

Paint Settings

A couple of useful settings for painters include loading and wetness. Loading affects how much paint is on your brush. A small loading will make your paint "run out" and you can only make short strokes. Wetness will blend your color as you are painting.

There are many other settings that you can play around with and use to tweak your brush to your heart's content. Experiment with them to see what kinds of brushes you can create!

TUTORIAL: Creating a Fantasy Illustration

For this dragon illustration, I took advantage of Procreate's amazing brush engine to create specific effects and textures.

The variety of brush settings is perfect for smoke and fire effects, and special textures in things like the dragon skin, rocks, and piles of treasure. It is a versatile app for fantasy illustrators and concept artists.

Final Image
For a great fantasy illustration, choose a fun subject matter. (If you ask me, dragons are pretty awesome!) Use bright colors, and include lots of elements (fire, treasure!) to test all those wonderful brushes on.

A Little About Procreate

The interface is pretty simple. There are gallery and settings buttons in the top left. In the top right are your tools—brush, smudge, eraser, layers, and color. To the side are size and opacity sliders. You can slide these as you are painting a stroke to change the size/opacity on the fly. Undo/redo buttons are below the sliders. You can create up to sixteen layers.

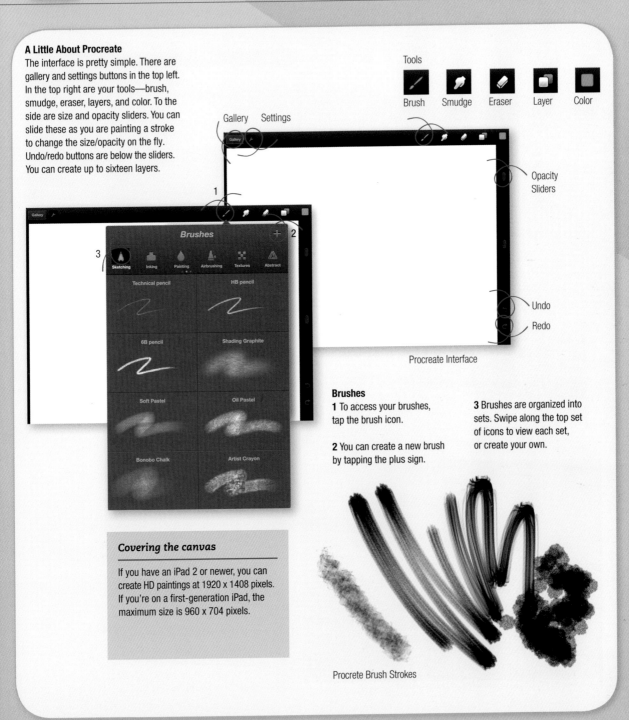

Tools

Brush Smudge Eraser Layer Color

Gallery Settings

Opacity Sliders

Undo

Redo

Procreate Interface

Brushes

Brushes

1 To access your brushes, tap the brush icon.

2 You can create a new brush by tapping the plus sign.

3 Brushes are organized into sets. Swipe along the top set of icons to view each set, or create your own.

Brushes

Technical pencil HB pencil

6B pencil Shading Graphite

Soft Pastel Oil Pastel

Bonobo Chalk Artist Crayon

Sketching Inking Painting Airbrushing Textures Abstract

Covering the canvas

If you have an iPad 2 or newer, you can create HD paintings at 1920 x 1408 pixels. If you're on a first-generation iPad, the maximum size is 960 x 704 pixels.

Procrete Brush Strokes

TUTORIAL: Creating a Fantasy Illustration

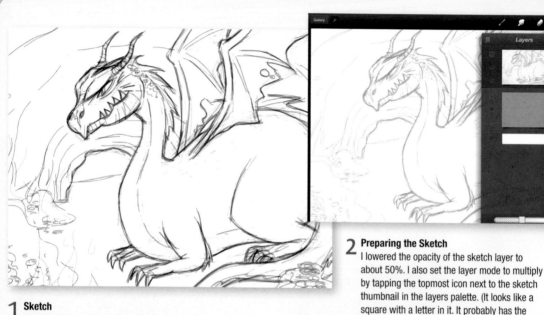

1 Sketch

You can draw a sketch within Procreate, but for this particular illustration, I imported a drawing that I had already made in another app. To browse your photo library, tap the wrench icon in the top left corner.

2 Preparing the Sketch

I lowered the opacity of the sketch layer to about 50%. I also set the layer mode to multiply by tapping the topmost icon next to the sketch thumbnail in the layers palette. (It looks like a square with a letter in it. It probably has the letter N in it for "Normal.")

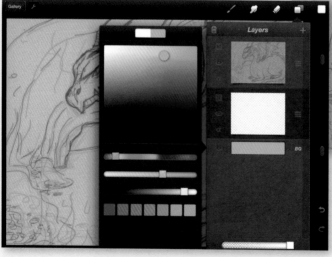

3 The bottom background layer is white by default. If you tap on it in the layers palette, you can change it to whatever color you want. I changed the color of my background to brownish yellow.

4 Basic Colors
Next, I established color and lighting using a basic round brush at high opacity. I used a low opacity brush to subtly bring out details in areas like the wings and face, but for the most part I kept it loose and simple.

5 Scales
I created a new layer on top and added texture. I started by creating my own custom brush for the dragon's scales. I opened up a new document, filled the background with black, and painted simple ovals in various sizes and shades of gray.

6 New Brush
I saved the image to my photo library and returned to my dragon painting, then created a new brush using my new image for the shape. For the grain, I chose rough texture from the Procreate library. I changed the scattering and spacing to better show the oval pattern. I used this to lightly paint scales on the dragon's skin.

TUTORIAL: Creating a Fantasy Illustration

7 More Texture
I made a couple more brushes in a similar manner using some watercolor splotches that I scanned from my sketchbook.

8 Applying the Texture
I used these brushes for the rock walls of the cave, and to generally add interest around the painting. I kept the brushes at low opacity and changed the size periodically for variety.

9 Details
Using a small pencil brush, I rendered details and cleaned up any messy areas. I started with the dragon's face and wings, and moved to the cave in the background and the rest of the dragon's body.

11 Fire and Smoke

Next, I decided to add some fire to the cave. I started a new layer and used one of Procreate's abstract brushes to paint a flame shape.

I locked the transparency of the fire layer by tapping the bottom icon next to the thumbnail in the layers palette (it looks like a lowercase "a"). This allowed me to paint on the layer without changing my flame shape. I added a lighter yellow to the bottom of the shapes to create a gradation of color.

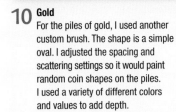

10 Gold

For the piles of gold, I used another custom brush. The shape is a simple oval. I adjusted the spacing and scattering settings so it would paint random coin shapes on the piles. I used a variety of different colors and values to add depth.

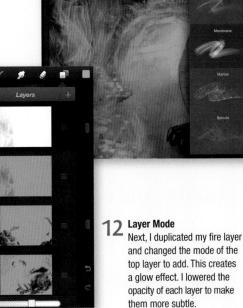

12 Layer Mode

Next, I duplicated my fire layer and changed the mode of the top layer to add. This creates a glow effect. I lowered the opacity of each layer to make them more subtle.

TUTORIAL: Creating a Fantasy Illustration

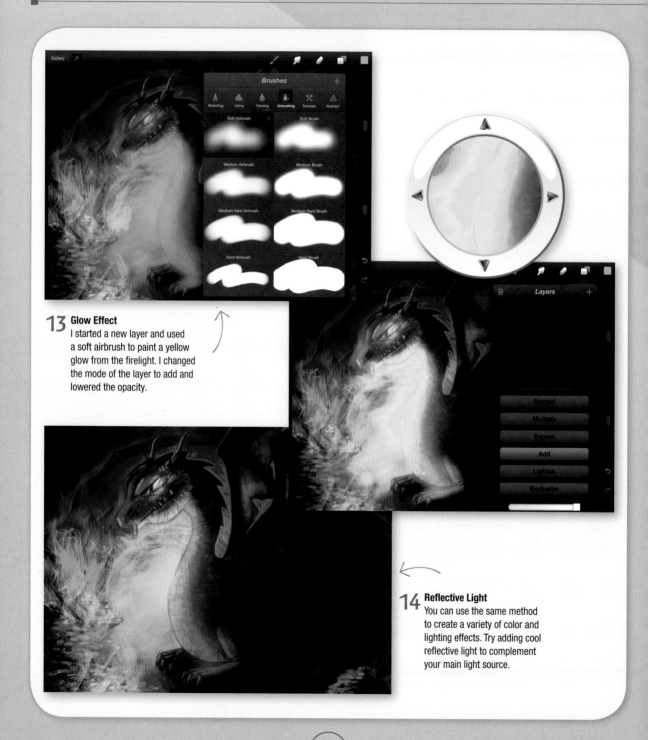

13 Glow Effect
I started a new layer and used a soft airbrush to paint a yellow glow from the firelight. I changed the mode of the layer to add and lowered the opacity.

14 Reflective Light
You can use the same method to create a variety of color and lighting effects. Try adding cool reflective light to complement your main light source.

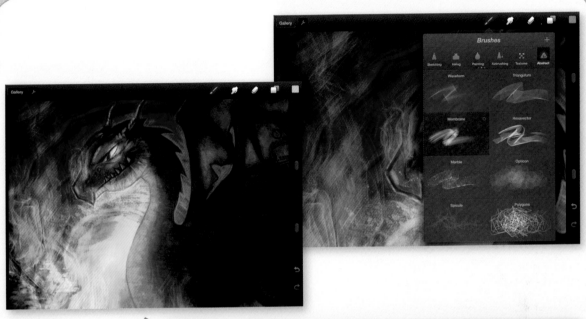

15 Smoke

Finally, I added another layer, and with the same brush I used for the flames, painted light gray smoke above the fire and coming out of the dragon's face. I changed the layer mode to add and lowered the opacity to finish the painting.

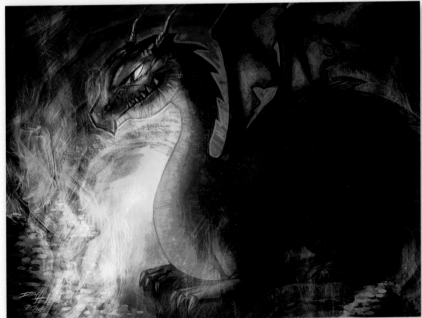

Final image

ARTIST SPOTLIGHT: Jorge Lacera

Jorge Lacera is a concept artist for Irrational Games, which is known for the acclaimed BioShock games. He has freelanced for such notable clients as Wizards of the Coast and Hasbro and is teaching concept art at the Rhode Island School of Design.

He uses his iPad to create a lot of character studies and designs. Jorge likes to integrate his sketches into his larger illustration process, and enjoys the versatility of apps like ArtStudio, which allow him to save layered pieces that he can open in Photoshop later. He recommends using Dropbox to easily move files from the iPad to the computer.

Jorge's tools and apps

Jorge's Tools of Choice
iPad 2, Targus and
Wacom Bamboo styluses

Jorge's Favorite Apps
SketchBook Pro and ArtStudio

BELOW AND RIGHT Jorge likes to use his iPad to create quick character design studies in ArtStudio or SketchBook Pro.

"One of the things that immediately drew me to the iPad was the ability to draw on my couch. It creates a far more intimate feeling than drawing on a Cintiq."

JL

Describing his process, Jorge often starts on a toned background and loosely establishes shadows and mid-tone shapes. He will then glaze colors using an overlay layer, then lay down final details and highlights with opaque color.

To fellow iPad artists, Jorge says, "Break out of your comfort zone. One of the truly freeing aspects of working on the iPad has been changing up my drawing style and techniques to fit within the existing format. Not having pressure-sensitivity at first can seem like a drag but it can also force you to work in bigger bolder strokes, giving you a deeper understanding of volume and mass."

Where to find Jorge's work

Check out more of Jorge's work at his website and blog

http://jlacera.com

http://lacera.blogspot.com

BELOW AND RIGHT Jorge starts loosely on a toned background and gradually builds up shapes and detail.

"Break out of your comfort zone. One of the truly freeing aspects of working on the iPad has been changing up my drawing style and techniques to fit within the existing format."

103

VECTOR ART

What is Vector?

Drawing software on both desktop and mobile devices is either pixel-based or vector-based. Pixel-based apps, which include most traditional drawing, painting, and photo-editing software, rely on little dots of color to make up the image. Vector-based apps are mathematical. They use tools like points, lines, curves, and shapes to define the image.

You can get a greater amount of subtlety and texture with pixels, but vector graphics are useful because they are scalable. This means you can resize them as much as you want without the image getting blurry. This is especially useful on a device like the iPad, where image resolution is a challenge.

Types of Vector Apps on the iPad

There are two main types of vector apps that I've come across on the iPad. They may not fall strictly into one of these categories, and may have features of both, but it is usually clear which philosophy the app favors. Keep that in mind when choosing a vector app that fits your style and work habits.

First, there are apps that mimic the traditional drawing and painting experience, just like other pixel-based apps, but which happen to be vector. Adobe Ideas, for example, creates vector-based files, but its emphasis is on drawing and inking. It has traditional pen and eraser tools, but is missing a lot of features that a typical vector artist might be used to.

Then there are other apps that are essentially mobile versions of larger desktop software like Adobe Illustrator. They will have features like paths and pen tools and shapes. They are meant for creating graphics, logos, illustrations, and other typical vector art. Inkpad and iDraw, which contain a lot of tools and path-editing capabilities, fall into this group of apps. For the purpose of this section, I am mostly referring to this type of artwork and software.

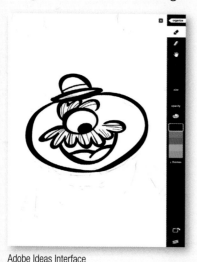

Adobe Ideas Interface

Desktop Adobe Illustrator Interface

Vector Art on the iPad

For the most part, I have found learning to create vector art on the iPad more intuitive than sketching and painting. With vector art, you work with lines, shapes, and points. Pressure-sensitivity is not an issue. Neither is pixel resolution. Vector artists will find the iPad to be a great mobile solution for their art and will adapt more quickly than a painter.

If you are new to vector software, the process is quite a bit different to other art apps. It is akin to working with paper cutouts instead of paint. Every stroke and shape is its own object that you can move around and adjust. Every shape has a set color, stroke, transparency, or gradient.

Tools

Vector apps tend to have a different set of tools than their pixel counterparts. Here's a look at a few of them.

Pen

This is not the type of pen that you can scribble with. The pen tool in vector apps creates paths by placing points on the canvas. It is meant for drawing precise lines and curves.

Brush or Freeform Tool

This tool is helpful for creating organic lines and shapes. You can apply a stroke and draw lines in a more traditional way. However, unlike brushes in traditional painting apps, vector brushes don't get much variation in texture, shape, width, or opacity. They make simple strokes at a specific uniform size and opacity.

Selection

Each mark you make in a vector graphic becomes its own object that can be changed, moved, and reshaped on the fly. You can use the selection tool to pick objects, tweak paths, and move points.

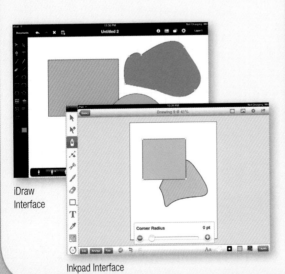

iDraw Interface

Inkpad Interface

TUTORIAL: Designing a Poster

Inspired by retro travel ads, I made this illustration of Neverland from the book Peter Pan. Vector art works great for graphic shapes and images, so I decided to create this poster in Inkpad.

1 Setting Up the Canvas

When you start a new document in Inkpad, you can choose from several default sizes, or specify your own. I picked the 11" x 17" tabloid size for a nice poster format.

Next, I imported my sketch that I created in another app. You can access your photo library by tapping the photo icon in the top right corner.

4 Arranging Objects

When I drew the island, it overlapped on top of my water. To move it farther into the distance, I wanted to place the shape behind the water, so I selected the island and tapped Arrange > Send Backward to move it back.

2 Resizing Your Drawing to Fit the Canvas

You will likely have to resize your drawing so that it fits your canvas. Select the scale tool then drag your finger on the screen to resize the drawing. If you need to rotate your drawing, you can use the rotate tool.

I lowered the opacity of the sketch layer and locked it. I then created a new layer underneath to begin my drawing.

Tip

Both the scale and rotate tools will perform differently when you add a second touch. When you start dragging while using the scale tool, place another finger on the screen to transform the object in non-uniform proportions (i.e. to make it fatter or taller). When using the rotate tool, the second touch will snap the rotation to 45-degree angles.

3 Establishing Shapes

When creating vector artwork, I like to start with the largest background shapes, and work my way forward. I set my stroke color to transparent, and changed my fill color as I drew different objects. The sketch layer above washed out the color, but at this point, I was not worried about specific colors because I would adjust them later. I just want to get the basic composition down.

I started off my poster by covering the entire canvas with a rectangle. This will later become my sky color.

Next, I placed a large blue shape for the water. To do this, I used the freehand tool so I could draw the shape of the wavy surface. I also used it to draw the island in the background.

DESIGNING A POSTER

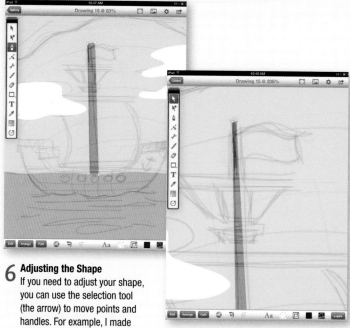

5 Using the Pen Tool

I continued to use the freeform tool for the rest of the island and the clouds. For some of the more geometric shapes, I used the pen tool.

With the pen tool, tapping the screen creates a point. When you tap the screen again, it creates another point connected to the first, and so on. If you tap and drag, it creates a curve.

Tip

If you draw a curve with the pen, and need to follow it with a sharp corner, as with my palm trees, you can tap the end point once to turn it into a corner point.

6 Adjusting the Shape

If you need to adjust your shape, you can use the selection tool (the arrow) to move points and handles. For example, I made the mast on my ship too thick, so I moved the points to make it thinner and taper it upward.

7 I continued to use the pen tool until I had completed the shapes for the palm trees and the pirate ship.

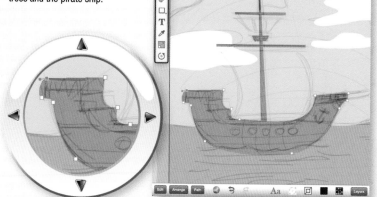

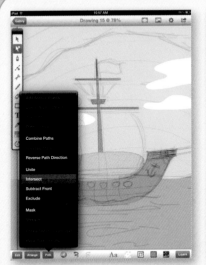

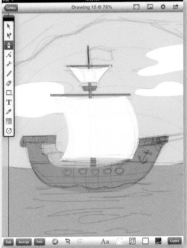

8 Path Tricks

To add depth to the ship, I created another color for the top side of the boat. I drew a shape roughly on top. I selected the boat and copied it by going to Edit > Duplicate in Place. Using the multiple selection tool, I selected this duplicate, along with the top color, then chose Path > Intersect. The resulting shape will only keep the intersecting portion of the two shapes and discard the rest.

9 Creating the Sails

I switched my color to white and used the pen tool to create the sails on my ship. For the curved rectangle, remember to tap and drag to create the curves and tap the end point to create a corner before you make your next curve. I then added red stripes using the technique from Step 8.

10 Creating the Windows

To create a window, I used the oval tool (drag and hold a second finger to create a perfect circle), then applied a stroke for the outline. I copied and pasted the rest of the windows.

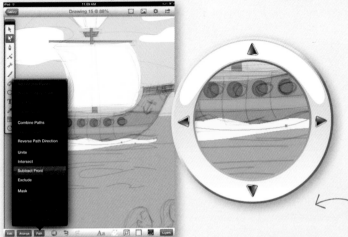

11 Making Waves

To finish the ship, I made a wave shape overlapping the bottom. I selected both this shape and the boat, then used Path > Subtract Front to cut out the wave shape from the ship, so it would look like it was floating on the water.

DESIGNING A POSTER

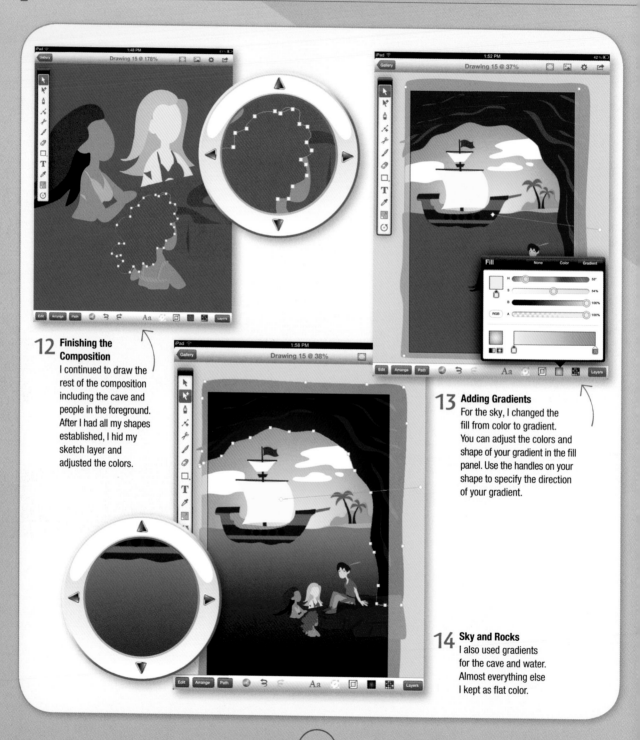

12 Finishing the Composition
I continued to draw the rest of the composition including the cave and people in the foreground. After I had all my shapes established, I hid my sketch layer and adjusted the colors.

13 Adding Gradients
For the sky, I changed the fill from color to gradient. You can adjust the colors and shape of your gradient in the fill panel. Use the handles on your shape to specify the direction of your gradient.

14 Sky and Rocks
I also used gradients for the cave and water. Almost everything else I kept as flat color.

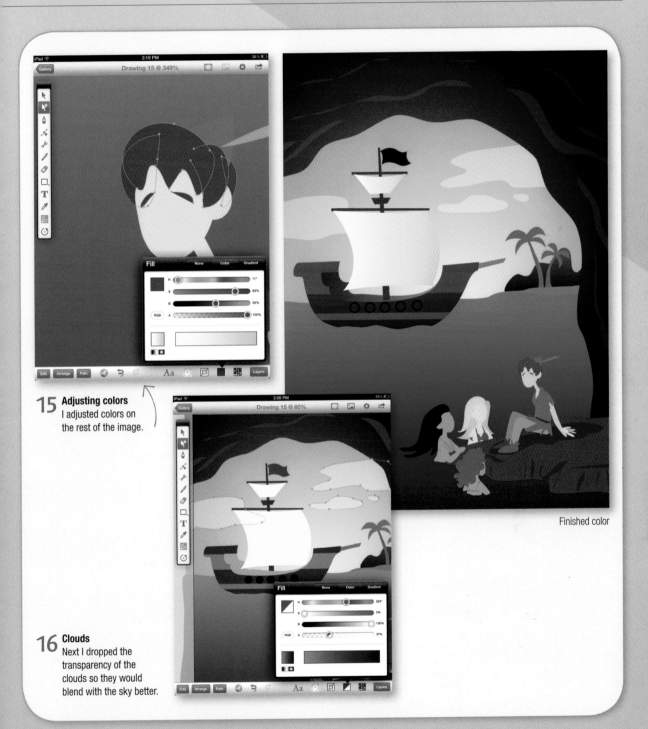

15 **Adjusting colors**
I adjusted colors on
the rest of the image.

16 **Clouds**
Next I dropped the
transparency of the
clouds so they would
blend with the sky better.

Finished color

111

DESIGNING A POSTER

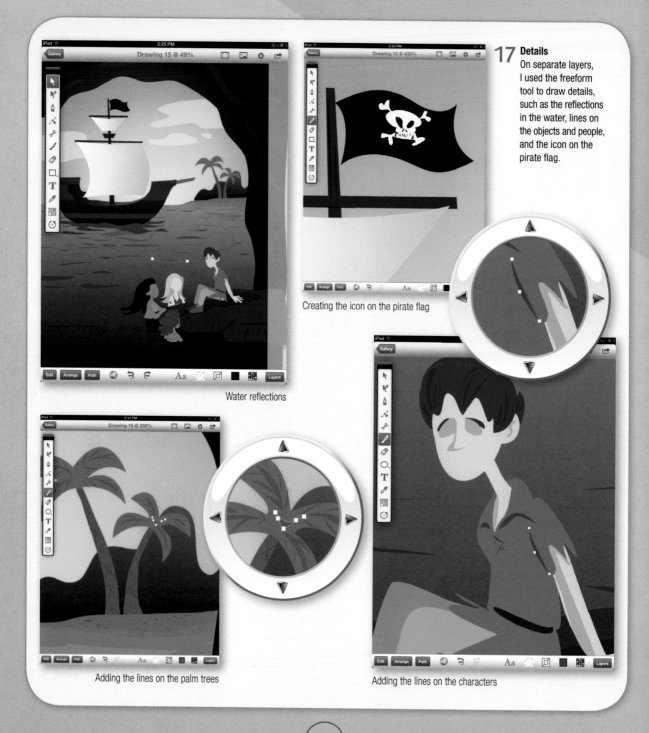

17 Details
On separate layers, I used the freeform tool to draw details, such as the reflections in the water, lines on the objects and people, and the icon on the pirate flag.

Water reflections

Creating the icon on the pirate flag

Adding the lines on the palm trees

Adding the lines on the characters

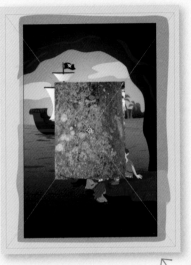

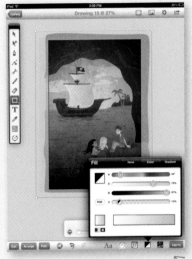

18 Adding Texture

On a new layer, I imported a textured image from my photo library. I used the transform and rotate tools to place it over the entire image, and then reduced the opacity of the layer to about 20%.

19

I also placed a giant yellow rectangle over the entire image, and reduced the opacity. This created a wash over the image to make the color a little more harmonious.

20 Type

Lastly, I added the text. You can change the size and font using the type panel. If you have a Dropbox account, you can import your own fonts by tapping the import button on the home gallery screen.

Final image

SHARING YOUR WORK

So what do you do once you've created all that art on your iPad? My iPad has become my own digital sketchbook. I like to keep my sketches, notes, and ideas organized for easy reference and usability. The iPad also works well as a portfolio to show to clients, customers, and art buyers. Say goodbye to lugging around huge portfolio cases and printing out endless sheets of paper.

Say goodbye to lugging around huge portfolio cases and printing out endless sheets of paper.

The great thing about the iPad is that it is so versatile. As an artist, you can use it for many things besides simply drawing and painting. Take advantage of this great device and organize your sketches, showcase your work to clients, and share your art with the world.

Take advantage of this great device and organize your sketches, showcase your work to clients, and share your art with the world.

CREATE A DIGITAL SKETCHBOOK

In my traditional sketchbooks, I write notes, draw designs, plan illustrations, and doodle weird ideas. This is useful for me because I can go back through the book and look for ideas for paintings and stories later on.

My iPad has become my digital sketchbook. However, I quickly realized that I needed a way to keep a unified collection of all my sketches. All of my drawings were spread out among multiple apps and formats. I needed to make it easy for me to go back and flip through pages just like my regular sketchbooks.

I use the photo library because virtually all art apps have the capability to save images there. It also makes sketches available to all my other apps, and it's easy to organize images into albums. For every sketch I make in whichever app, I save a copy to my photos.

Creating a Photo Album on Your iPad

Photos automatically get pooled into one big Saved Photos album. To keep things organized, I created an album for my sketches.

In the Photos app, tap the action button in the top right corner (it looks like a square with an arrow coming out of it).

Creating a New Album

Tap Add To . . . and select Add to New Album, and type in a name. I typically organize my albums by date.

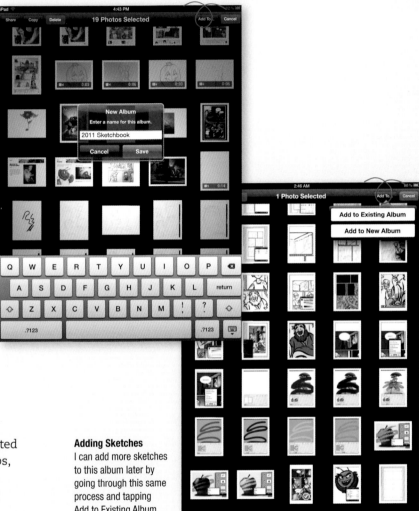

Create a Dropbox Folder

Alternatively, you can use Dropbox to store and sync sketches. Dropbox is integrated into several popular art apps, including SketchBook Pro, Inkpad, and ArtRage. Using Dropbox has several advantages, such as online backup and accessibility from your desktop, iPhone, and the web. You can also save other formats besides flattened JPEGs or PNGs. However, it can be more of a hassle to organize

Adding Sketches

I can add more sketches to this album later by going through this same process and tapping Add to Existing Album.

depending on the app. Some apps won't let you choose a specific folder to upload to, so you have to manually organize files on your desktop later to keep sketches together.

MAKING WORK FOR CLIENTS

One of the most common questions I receive from other artists about drawing on the iPad is this: "Can I use the iPad for creating professional illustrations and paintings?"

When someone asks me this question, they usually want to know two things:

1 Can you create professional-LOOKING work on an iPad?

2 Can you produce professional-quality files that are appropriate for delivering to a client?

In regards to the first question:

Yes, you can create art on the iPad that looks just as good as any of your other work.

I hope the artwork in this book convinces you of that. I will admit that I had my doubts when I first picked up an iPad, but I've long gotten over it. I've been able to reproduce many styles, from cartoons to fine art paintings to comics and children's illustration. My early iPad art was rough, but I would proudly place some of my more recent work next to my portfolio pieces.

But, it takes practice. Don't buy an iPad and expect to be creating your client work on the road the next day. I kind of compare it to first learning how to use a standard graphics tablet. There is a disconnect in hand-eye coordination that takes getting used to. However, it does go away with practice. Nowadays, I am as comfortable on an iPad as I am on my Cintiq, but keep in mind that I've owned my iPad for two years now.

Then there is the software. You have to rethink your process to adjust to the iPad's limitations. Even experienced digital painters are going to go through a bit of a learning curve. It also depends on your style, as some methods will be easier to replicate on the iPad than others.

However, it can be done, and it is a ton of fun once you get used to it.

And as for the second question:

Yes, you can create professional-quality files that you can send to clients.

Sometimes.

High-Res Images

Creating high-res images on the iPad is quite limited. However, there are a few solutions available:

Retina Display Support

The hardware has greatly improved since the first iPad was released. With the new retina display, a lot of apps are moving to higher resolutions. The native 2048 x 1536 pixel resolution is just under 5" x 7" at 300 dpi, which is good enough for small spot illustrations. Some apps may even be able to work slightly higher. But of course, you need at least a third-generation iPad or above to take advantage of it. Most apps are either not compatible or use lower resolutions if you're on an older iPad.

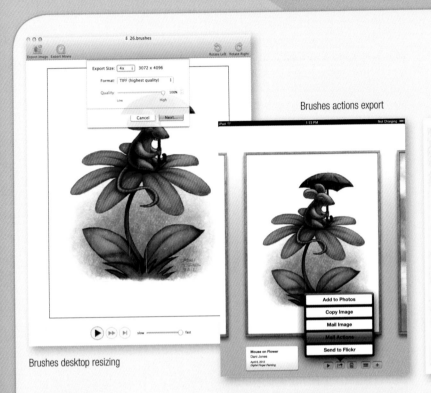

Brushes desktop resizing

Brushes actions export

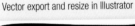

Vector export and resize in Illustrator

Script Export

Several apps like ArtRage and Brushes have the ability to record your strokes as you paint, which can then be exported as a script. Both ArtRage and Brushes have desktop software in which you can "rebuild" your painting on your desktop computer at higher resolutions. It is still not as good as native high-res support, but it is a whole lot better than simply upsizing a tiny image file.

Go Vector

Of course, resolution is only a problem if you are a pixel artist. If you work with vectors, you should have few issues because you can resize the artwork to any size. Inkpad works great and exports files you can take right into Adobe Illustrator. And these apps are not just for the typical vector artist either. Adobe Ideas draws very smoothly and I like using it for line drawings. Other apps, such as SketchBook Ink from the makers of SketchBook Pro, feature more organic brushes and effects that are particularly suited to more traditional inkers and painters.

I have to admit that creating high-resolution artwork is still quite limited, but if anything, the iPad is a great way to make concepts or get a head start on paintings to finish up later on your desktop. All in all, most artists seem to be under the impression that the iPad is not good enough for professional work, and I think that is not the case at all; you can get a lot farther than you might think.

BUILDING A PORTFOLIO

The advantages of using an iPad for a portfolio presentation are obvious—it is easy to organize and update, is incredibly versatile, boasts a large, attractive screen, and can feature a variety of media such as video and sound in addition to images.

That being said, I would be cautious about which situations you use your iPad in. Although an iPad is incredibly convenient for you, remember that it is your client that you must tailor your presentation to. I still believe a traditional printed portfolio works best for individual interviews and critiques. Many art directors prefer to see images in print, especially if they work for a print-heavy industry such as magazine or book publishing. Also, the iPad screen is a bit small for a professional presentation in a one-on-one setting, in my opinion.

However, I believe there is a place for the iPad as a portfolio. If you need to show off a storyboard reel or a website design for example, it is perfect. It is also a great device for casual situations such as a comic convention or illustrator's conference where you are meeting a lot of different people and need a way to show off your artwork on the fly. The iPad is also great for public presentations, since you can plug it right into a projector, or display it on a stand on a table.

Methods for Creating a Portfolio

Photo Library
The simplest method for creating a portfolio on your iPad is probably the Photos app. Simply make an album or folder of images on your computer, and sync it. The Photos app works great because it has pinch, zoom, swipe, and slideshow capabilities already built in. You can create several albums or folders for different styles or clients. The resulting presentation is both simple and effective.

iPhoto album

iPhoto journal page

iPhoto

Apple's iPhoto app provides some fancier options for slideshows and presentations. The Journal feature, for instance, creates a nice page presentation with image thumbnails and captions. It also provides basic image-editing tools.

PDF portfolio

PDFs

PDF files can be read in iBooks or any number of PDF readers. You can make different files for different clients. PDFs are particularly handy because they can be emailed directly to your client in one neat package.

BUILDING A PORTFOLIO

iBooks

If you want to create a portfolio that is a little fancier than a PDF, you can also create your own iBook. Apple provides a piece of software called iBooks

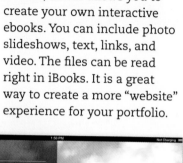

Author, which allows you to create your own interactive ebooks. You can include photo slideshows, text, links, and video. The files can be read right in iBooks. It is a great way to create a more "website" experience for your portfolio.

Portfolio in iBook iBook layout

Portfolio Apps

There are several dedicated apps that are specifically for artist portfolios. These will cost you money, but make up for it in convenience and features, such as customization, themes, multiple galleries, and Dropbox or Flickr integration. Some examples of portfolio apps include Portfolio (by Britton Mobile Development), Portfolio To Go (by Nick Kuh), and Foliobook (by Architek Ltd).

Website

Another way to show a portfolio on the iPad is to simply use a website. Of course, it is not always the ideal solution because you need an internet connection. However, it is a highly versatile and customizable way to showcase your work if you have website building skills. It works best if you format the site so it looks attractive on a mobile browser. You can even create a web app that looks and acts just like a standard iPad app, which users can then download and even access offline.

iBook portfolio

Website portfolio

Presentation

And finally, if you're going to use your iPad as a portfolio, remember that presentation counts! Everything from the accessibility of your images to the outside appearance of your device says something about you as an artist.

Keep It Clean
Clean up that greasy screen! And if you bring your iPad to an event with lots of people, remember to bring along some cleaning cloths for wiping down your device periodically.

Organize
Clean up the home screen, organize app icons, and get rid of anything you don't want your clients to see. Nothing says unprofessional like a stray fart app.

Make It Pretty
Treat your iPad just like any other portfolio book. Invest in a professional-looking case for interviews, and a stand for table presentations.

Image Resolution
Make sure your images look good on the iPad screen. I recommend using images at least twice the resolution of your screen so that clients can zoom in on your images.

Titles and Info
To add a little individuality to your presentation, think about including some title pages and contact info in addition to the images themselves. You may also want to include other info in your pages, like titles, medium, or extra info.

Griffin A-Frame stand for iPad

iPad Smart Covers

SHARE ONLINE

Once you have created a collection of beautiful artwork, it's time to show it around! The web has been one of the most important tools for promoting my artwork. Here are several ways you can share your work directly from your iPad.

Social Networks

Twitter is built right into iOS, which means you can tweet images directly from your photo library, and even from within some art apps. Some apps, like ArtRage, also have Facebook integration.

Photo Sharing Sites

I like uploading my art to my Flickr account because it makes my images easily available to use on my website, blog, or post to social networks. Flickr is also integrated into several portfolio apps.

Instagram is incredibly popular and easy to use. It automatically posts to several social networks at once, and you can also apply retro filters and effects.

Blogs

The simplest blogging tool for posting images is probably Tumblr, which is optimized for quick posts and snippets of content. Popular blogging platforms WordPress and Blogger both have iOS apps.

Downloadable Portfolios

I've already mentioned that you can use your own iPad to transport your portfolio to interviews and events. However, don't forget that your clients may have iPads too! Having a downloadable portfolio on your website is a nice, convenient

way for potential clients to access and save your portfolio. Simply make the file, upload it to your web server, and put a link to it on your website or blog. PDF, iBooks, and ebook files are all great universal formats that can be easily read on any iPad.

If you want to keep your portfolio handy for quick emailing to clients, I recommend keeping a file in a Dropbox account. You can use the Dropbox app to send the link to clients whenever you need it.

You can tweet images from anywhere in iOS, including the photo library.

FINAL WORDS

If you have reached this page, you have probably finished skimming through this book and looking at all the art. You're hopefully eager to start drawing, having shelled out a good chunk of money for an iPad, a stylus, and a few apps.

Let me remind you of that day in April 2010 when I first received my iPad and was in the exact position that you are in (minus the cool book). I, the experienced illustrator and digital painting guru, couldn't make beans on the iPad and was ready to give up on it as a drawing device. It just wasn't ready.

But, as I came to find out, it was me who wasn't ready. Each time I sit down with my iPad, I discover something new. With a little practice and time, it became exactly the kind of drawing device I had always hoped it would be. There are still improvements that can be made, but I have a feeling those doubts will all be squashed within the next few years.

So, as you sit down and get ready to draw, don't let those first ugly sketches get you down. Be open to a new experience. Discover new processes and learn new skills. And most of all, have fun.

Happy drawing!

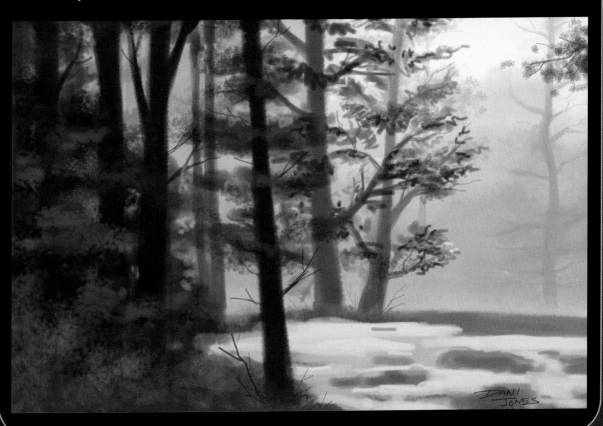

GALLERY

In this book, I have tried to demonstrate as many styles and processes as I can. I have discovered that the iPad truly is one of the most versatile tools that an artist can use, something that is driven home when I see other artists—sketchers, painters, illustrators, comics creators—producing great work on the iPad. As a taste of what's out there, here is a collection of artwork created on the iPad.

> The iPad truly is one of the most versatile tools that an artist can use . . .

ABOVE AND RIGHT Work by Octavio Perez, Robh Ruppel, and Jason Tammemagi.

ARTIST: Petra Van Berkum

www.petravanberkum.nl

Procreate

ARTIST: Octavio Perez

Brushes

"Guinea Fowl"

ARTIST:Jesse Richards

www.jesserichards.com

Sketch Club

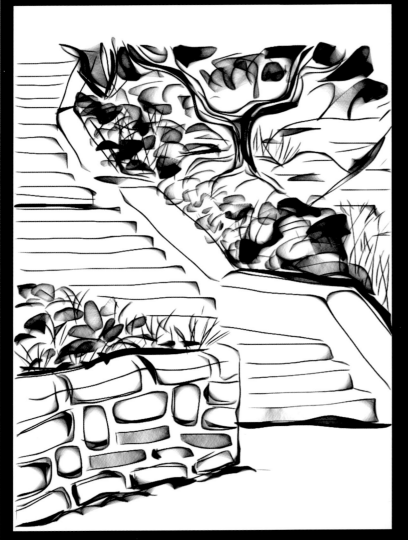

ARTIST: Jeff Porter

jeffporterart.com

ArtRage

"Christmas"

ARTIST:Jason Tammemagi

jasontammemagi.com

Brushes

"Terror of Godzilla"

ARTIST: Paul Clay

www.alphawham.com

Sketchbook Pro

"Funky Jumper"

"Grumpy Jumper"

Sketchbook Pro

"Drummer"

ARTIST: Steve Whittingham

Adobe Ideas

"Bodhi"

ARTIST: Sumit Vishwakarma

www.sumitstudio.com

Sketchbook Pro

"Let it Snow"

ARTIST: Robh Ruppel

ArtStudio

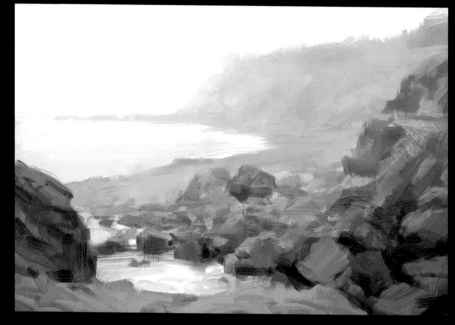

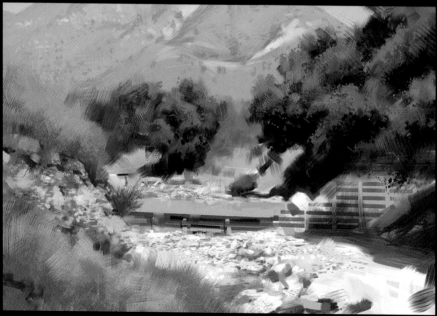

ArtStudio

ARTIST: Robh Ruppel

ArtStudio

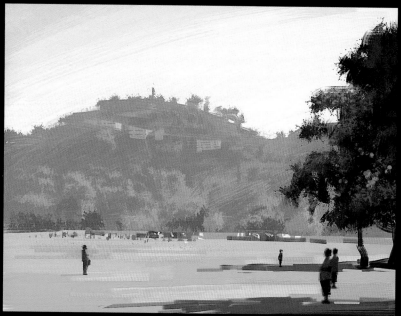

ArtStudio

INDEX

CREDITS AND ACKNOWLEDGMENTS

Artist Credits

Spotlighted Artists

pp. 46–47: images © Eric Merced;
ericmerced.com
pp. 58–59: images © Marc Scheff;
marcscheff.com
pp. 68–69: images © Fraser Scarfe;
fraserscarfe.co.uk
pp. 78–79: images © Reed Bond;
reedbond.com
pp. 88–89: images © Will Terry;
willterry.com
pp. 102–104: images © Jorge Lacera;
lacera.blogspot.com

Gallery Artists

p. 126 (left) & p. 129: image © Octavio Perez
p. 126 (right): image © Robh Ruppel;
broadviewgraphics.blogspot.com
p. 127: image © Jason Tammemagi;
jasontammemagi.com
p. 128: image © Petra Van Berkum;
petravanberkum.nl
pp. 130–131: images © Jesse Richards;
jesserichards.com
p. 132: image © Jeff Porter;
jeffporterart.com
p. 133: image © Jason Tammemagi;
jasontammemagi.com
pp. 134–135: images © Paul Clay;
alphawham.com
p. 136: image © Steve Whittingham;
side-on.co.uk
p. 137: image © Sumit Vishwakarma;
sumitstudio.com
pp. 138–141: images © Robh Ruppel

Author Acknowledgments

Special thanks to the folks at Ilex Press for their wonderful editing and design skills, and for creating a beautiful book. Thanks to Will Terry, Eric Merced, Marc Scheff, Fraser Scarf, Jorge Lacera, and Reed Bond for sharing their insight and skills, and to the gallery artists for contributing their awesome artwork. To all the hardware and software developers that are out there, dedicated to improving technology, computing, and digital painting—thank you. You make my life much more fun. And to my family, for always supporting me and tolerating my mental and financial obsessions with computers, tablets, apps, and art!

DEDICATION: To Steve Jobs, for helping along the computing revolution.